CLASSIC CATS BY GREAT PHOTOGRAPHERS

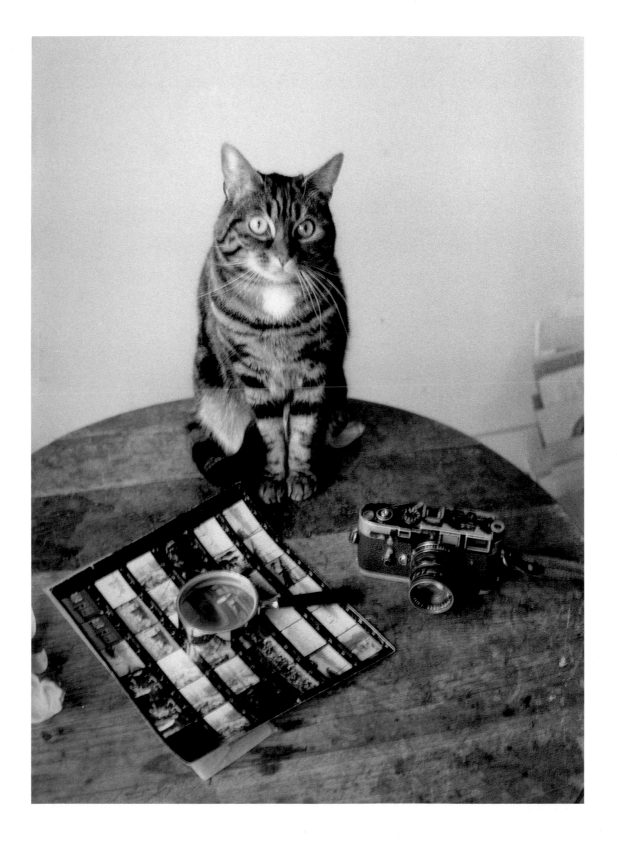

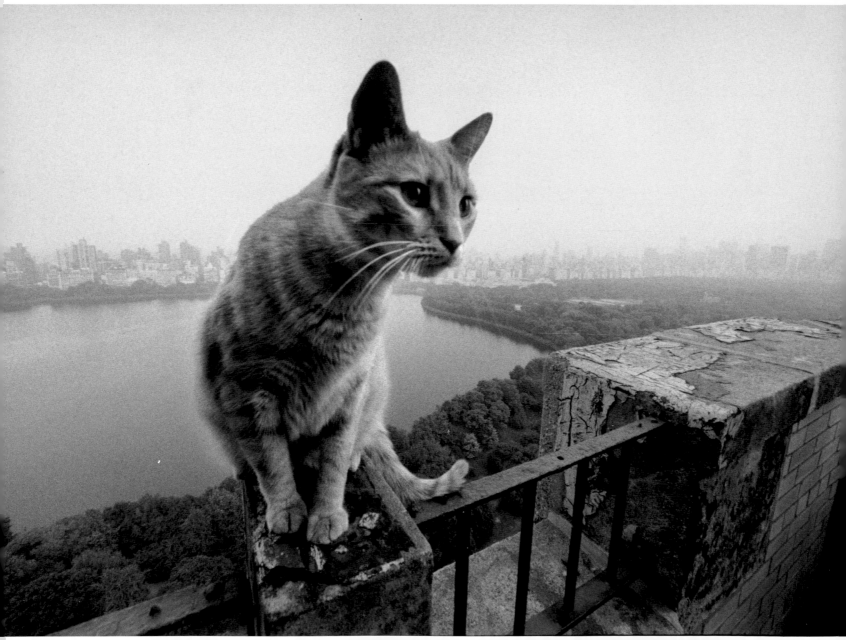

GREAT PHOTOGRAPHERS

CONCEPT, COMPILATION, AND TEXT BY JULES B. FARBER

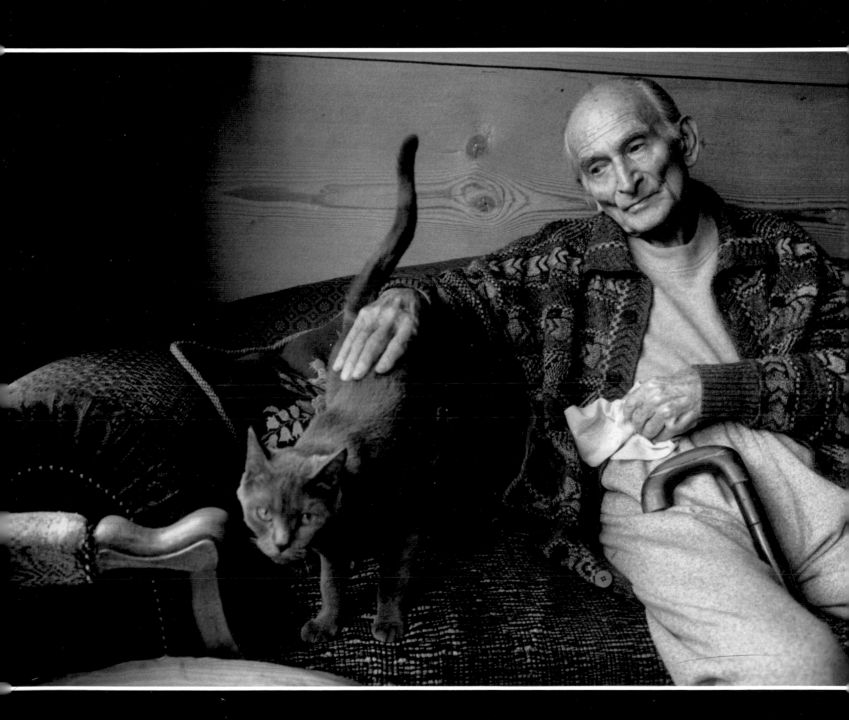

Flammarion

CONTENTS

To P.C. and M.C.

Page 1: ÉDOUARD BOUBAT, His cat, Noëlle, found in a garden on Christmas Day, Paris, 1990
Page 2: BRUCE DAVIDSON, Central Park lake, New York, 1992
Page 3: MARTINE FRANCK, Balthus, Rossinière, Switzerland, 1999
Facing page: ELLIOT ERWITT, Hamburg, 1987

PREFACE

Our house cat, Minimouche, lived to the incredibly ripe old age of twenty-three years! During that period of over two decades, while our three children were growing up, I must have taken hundreds of photos, from her earliest kitten days to her last years of the *troisième âge* as a senior feline. I am an amateur photographer, and the prints, first in black-and-white and later in color, never got further than some family albums, or were stacked in big, brown paper bags, still waiting to be organized and filed after all those years. Even with the dawning of the digital age, nothing changed. I continued taking cat photos, but now they are on CDs, which are often misplaced or forgotten. Thus, with no claim to photographic greatness, none of my cat images are included in this book. A French friend of mine told me I was a true practitioner of *chatographie*, a term dreamed up in the mid-nineteenth century to denote a cat lover and amateur cat photographer. I guess I fit the bill.

This book was born out of the conviction that so many of the world's truly great photographers must have taken wonderful photos of great cats during their careers. So I started to track down those works of art, hoping also to find some relatively unknown, unsung, and even unpublished photos hidden away in archives. The search began to accumulate a wealth of exceptional images and information for people who love cats and people who love photography: a marriage of the two.

The leading photo agencies provided me with hundreds of cat images by internationally renowned photographers. This overabundance of fantastic images grew to over one thousand during my three years of research, which—after poring over all the possibilities, discarding, cataloging by subject, and changing—was honed down to about 120. Libraries, museums, archives, photographic centers, photo galleries, photo editors, photographer friends, and many photography connoisseurs helped me dig up pictures and gave me tips on where to look for elusive or unknown prints.

DAVID DOUGLAS DUNCAN, Coral Gables, Florida, 1936
Of course, there are photographers who truly prefer dogs to cats. David Douglas Duncan is one of them. D.D.D.—a combat photographer for the U.S. Marines, who photographed the world for *Life* magazine, had an intimate friendship with Picasso (everyone knows his unforgettable shot of the artist in his bathtub), and published numerous books on everything from war and politics to art—was never without a faithful canine companion. On the subject of cats, he said: "I like their independence." However, he always kept his distance and only took one cat photograph in his life—and that was in 1936. But what a photo! "I'm allergic to some," he admitted.

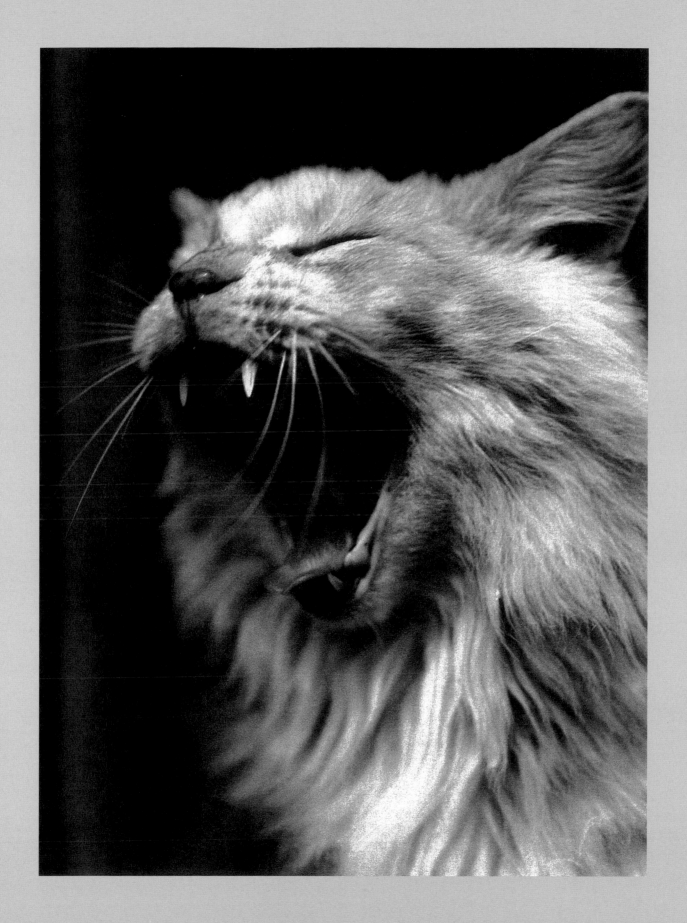

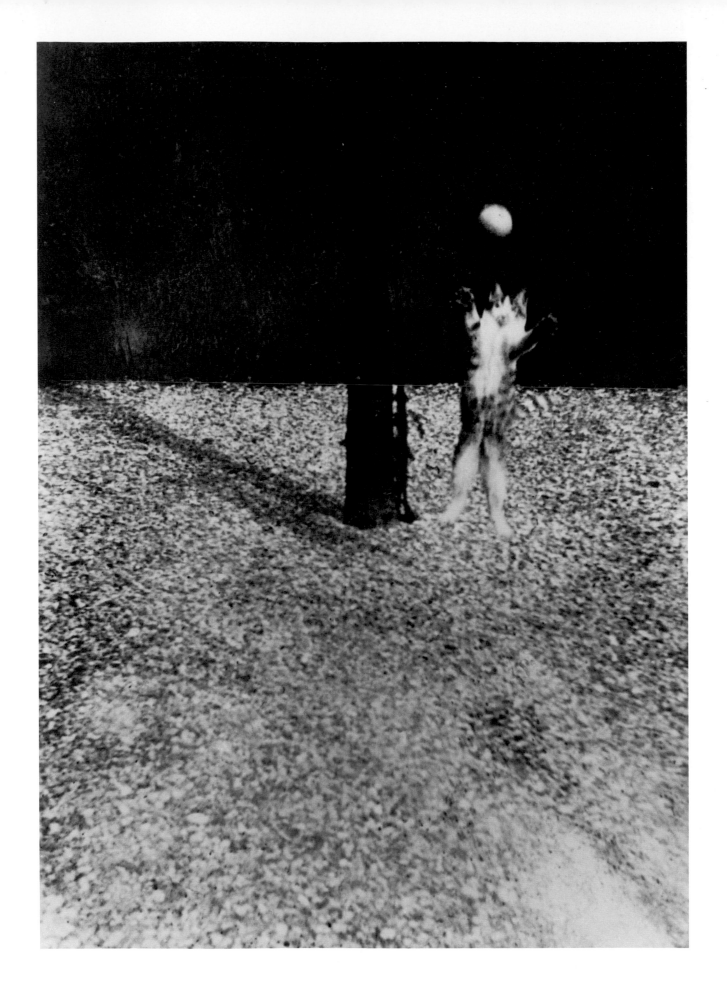

I was also determined to find cat photos from artists I admired. Though many of the people I queried insisted that the American expatriate artist, Man Ray, had not taken any cat photos, a tenacious museum archivist helped me find two prints: a portrait of his fellow surrealist, Georges Malkine, with a cat cradled in his arms, and a close-up of a reclining feline. Eugène Atget took hundreds of photos capturing the atmosphere and architecture of empty Parisian streets, which he sold to artists and stage designers. It seemed highly unlikely to me that a cat had never crept into view. A persistent curator searched files and, sure enough, there was a sole exception. The prized print shows not one but *two* cats sitting calmly near a house in cours de Rohan, looking defiantly into Atget's lens. In contrast, the Hungarian André Kertész went out looking for cats to photograph for his extensive Paris street series.

I had been on a three-month-long wild-goose chase for a photo erroneously signaled by a very authoritative source. The elusive picture supposedly showed Hitler's infamous propaganda filmmaker, Leni Riefenstahl, with Marlene Dietrich and Anna May Wong—and a cat—and was taken by the great Alfred Eisenstaedt. It turned out that "Eisie" had indeed snapped these three ladies at an opera ball in Berlin but, obviously, without a feline. After this fruitless pursuit that took me to New York, London, Paris, and Berlin, I was pleased to find a touching double portrait of his eminent fellow *Life* photographer Margaret Bourke-White and her kitten.

Sometimes a photo was so embedded in my mind that I spent days trying to procure it. This was the case with a K.J. Germeshausen multi-image cat, twisting and turning before landing on all four of its paws. I eventually secured a print from a photo agency which had taken over the archives from defunct colleagues, but they had no additional information about it. Finally, on the Web, I traced a passing reference to the photographer's tenure as a Professor of Engineering at the Massachusetts Institute of Technology. This led to the MIT Museum archives, which revealed that he had developed improvements in stroboscopic technology, opening the door for numerous photographic possibilities, including "stop action" and "multi-flash." I could only assume that the photo I had found without any identifying details must have been taken while he was experimenting with this process. I decided to let the image speak for itself.

The astonishing image of a shrieking cat, vaulting into the air after a rat had gnawed on its tail, intrigued me, but the photo agency that had distributed it worldwide had long since closed its doors and the archives had been dispersed. Only the photographer's name— Gilbert Barrera—remained to identify this mysterious snapshot. All efforts to find out more about Barrera have proved fruitless.

JACQUES-HENRI LARTIGUE, *My Cat, Zizi*, Paris, 1904–05

Happenstance was also sometimes the cause of my finding a great picture. In talking to a friend of mine, who was a photo editor for *Time* magazine, in Manhattan, she suggested a photo of T.S. Eliot and his white-pawed black cat outside a London theater, taken by her father-in-law, Larry Burrows. This cat was the inspiration for Eliot's anthology of poems, *Old Possum's Book of Practical Cats*, which later became the Broadway hit musical *Cats*. I remembered Burrows as the *Life* photographer of the Vietnam War, whose poignant photo *Reaching Out* was widely published. In 1971, at the age of forty-four, he lost his life when his helicopter was shot down by the North Vietnamese over the Ho Chi Minh Trail.

Searching for the earliest cat photographs, I went to the Burgundian town of Châlon-sur Saône's Nicéphore Niépce Museum, named after the local who invented photography. In 1816, he developed a new photoengraving and photographic process, called "heliography." He died soon after joining forces with Louis-Jacques Daguerre, a Parisian painter and decorator who launched the daguerreotype in 1839—and modern photography was born. The absence of cat images by Niépce or Daguerre in the collection of more than two million photos was not unexpected, since obviously it would have been difficult to find any cat patient enough to pose for the six to eight hours necessary to capture an image using the early photographic technologies. They had to settle for still lifes and landscapes. But I did find later stereoscopic daguerreotypes showing felines sipping milk or looking coyly at the photographer.

Still on the nostalgic tour, I looked into the well-documented legacy of Félix Nadar, a caricaturist, writer, and pioneer in photography who, beginning in 1851, developed new techniques such as artificial light, which he used underground in the Parisian catacombs. He was the first aerial photographer, taking shots from a balloon over Marseille, proclaiming that photography should be elevated to the height of art. Whether or not he had his favorite feline with him, high above the Mediterranean port city, is not known, but he and a cat can be seen reclining comfortably together in a self-portrait on a park bench.

As a collector of photographs, I used my gallery contacts to turn up some valuable leads. A Berlin source told me about a 1928 photo by Umbo—born Otto Maximilian Umbehr in 1902, and one of Germany's most famous photographers in the twenties—which Sotheby's London had auctioned in 1997 for an exceedingly high hammer price of £62,000 ($100,617 at the time). I was extremely curious to know who had bought the work for such a high price and why. Contacting another Berlin gallery, I found out that they held the copyright, jointly with Umbo's daughter, Phyllis. To my surprise, I discovered the photo had been acquired by none other than Sir Elton John for his prestigious collection. He graciously sent me a print for reproduction.

NADAR, Self-portrait, 1854–60

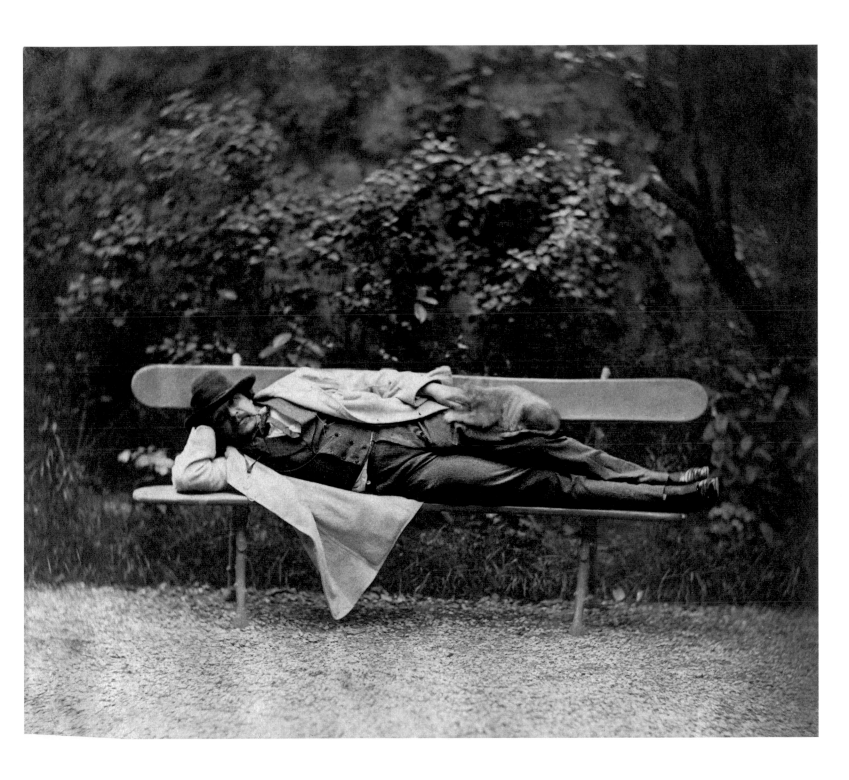

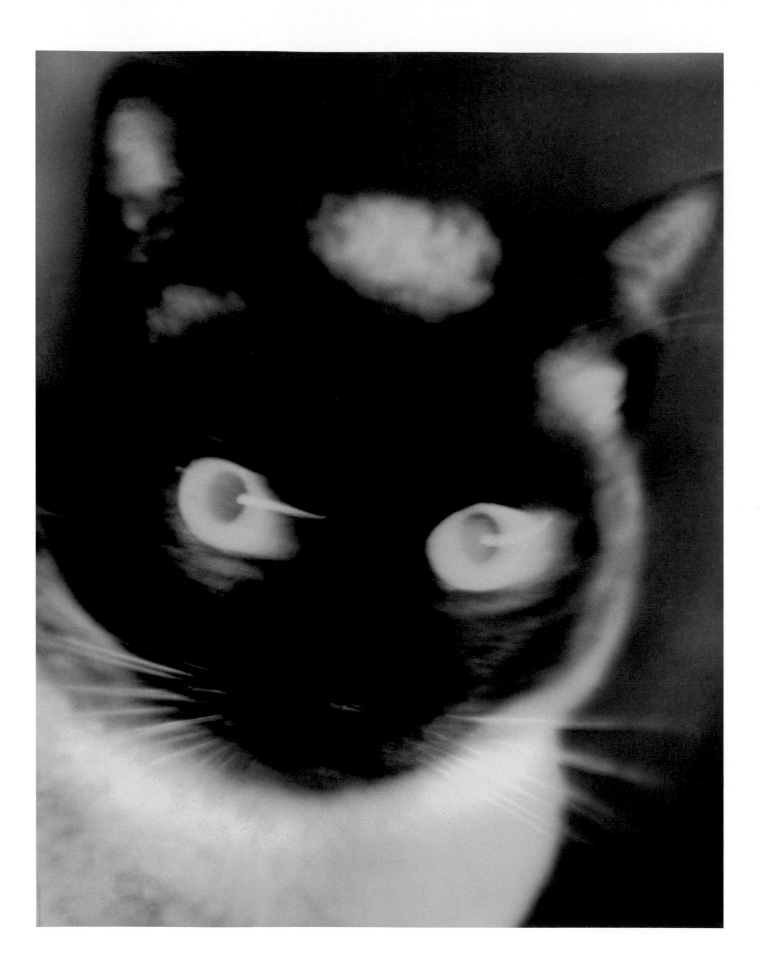

Still curious to find out more about the photo, I contacted Phyllis, who was in Estonia when I spoke to her. She suggested that I get in touch with Herbert Molderings, Professor of Art History and the absolute expert on Umbo. Professor Molderings explained:

The Persian cat, Mimi, belonged to Ruth Landshoff, a famous movie actress and writer in Berlin's bohemian world of the twenties, and Umbo's favorite model. The cat moved, blurring the image and making it look so mysterious. Being one of the few photos which survived the bombing of his Berlin studio, it was rare; a unique print of unique quality and absolutely worth the high price. Umbo has been rediscovered!

As I became more and more aware of the poignancy of these photographic works of art, I also became interested in the lives of the people behind the camera. I realized that most photographers had, at one time or another, zoomed in on cats. On occasion, the photograph was the result of a casual encounter, with the feline suddenly appearing in the photographer's objective; some photographers went out looking for cats, while others tried everything to keep them out of their shots. Like everyone else, among them are cat-lovers, cat-haters, and those who are simply indifferent. I wanted to get to know them firsthand and set out to interview a number of photographers, or in some cases their widows, about their feelings toward cats, the difficulties in photographing them, and the pleasures; the fascination, and the mystery, as well as the inspiration brought on by their mystical dimension. I have inserted these reflections—brief professional and personal commentaries—throughout the book.

Delving into the history of the cat, researching the beginnings of photography, entering into the vision and techniques of photographers, has made my journey into the seductive world of cats and their portrayers more exciting, rewarding, and stimulating than I ever could have imagined. Hopefully the reader will enjoy this book of "catography" as much as I have enjoyed compiling it.

Jules B. Farber

UMBO, Mimi, Berlin, 1928

A CAT'S WORLD

Egyptians had always been credited with the domestication of the cat, some five thousand years ago, until French archaeologists, in 2004, excavated a grave that was 9,500 years old, with evidence of human-feline bonding. Their discovery in a Neolithic village in Cyprus revealed the remains of a thirty-year-old person (sex unknown) with the curled-up skeleton of an eight-month-old kitten, probably a tom, placed intact in its own small pit, with no sign of having been slaughtered or mauled by another animal. It appears to have been killed intentionally for burial, inches away from its owner. The skeleton's measurements suggest a type of African wildcat known as *Felis silvestris lybica*. It might have looked like a tabby, with a striped, brownish or sandy-yellow coat and a ringed tail. Its face and teeth were bigger than those of today's domestic cat, *Felis catus*, and it had longer limbs.

There were signs of a burial with religious significance, and the grave contained many objects never found in any other grave of that period in Cyprus. The rich offerings indicated a special social status, along with spiritual links with the cat. A statue of a cat, also dug up in the village, resembled clay and stone figurines found at sites in Syria, Turkey, and Israel.

Good news for cat people: their pets' ancestry can be traced back to prehistoric cat lovers, although the bond often meant going off to the hereafter together. The first Neolithic farmers, who probably came to Cyprus looking for fresh land, brought animals with them, including cats, which were not native to the island.

The bad news: Sheep, goats, and pigs were domesticated in the Middle East more than ten thousand years ago, while dogs have an even longer history, dating back thirteen thousand years. Archaeologists in Israel uncovered evidence of many intentional burials of pet dogs with humans at even earlier sites.

A consolation: The *Encyclopaedia Britannica* reveals that all cats are members of the *Felidea* family, which split from other mammals at least forty or fifty million years ago, making them one of the oldest mammalian families.

The cat's most ancient forefather was probably an animal that looked like a weasel, called *Miacis*. Supposedly, *Miacis* is the common ancestor of all land-dwelling carnivores, including dogs and cats; but evidently cats existed for millions of years before the first dogs.

For feline fanatics, a memorable feat among Egypt's many cultural accomplishments was the domestication of cats. The grandfather of all the world's cats can be traced back to 3000 B.C.E., when the African Wildcat—a black-striped yellow cat—settled in. In actual fact, the Egyptians' domestication of cats came about by accident. It got started over five thousand years ago in the Nile Valley, in what was then Upper Egypt and is now Sudan. Former nomads began planting crops and settling in agrarian communities, with their annual or semiannual harvests stored in baskets. Rats, mice, and other vermin, attracted by the grain, were devastating the farmers' food supplies until the African Wildcat wiped them out. The farmers soon realized that their new savior could be approached easily and held. Stroking their

SIR CECIL BEATON, Lady Aberconway's cat, Bodnant, U.K., 1950

14

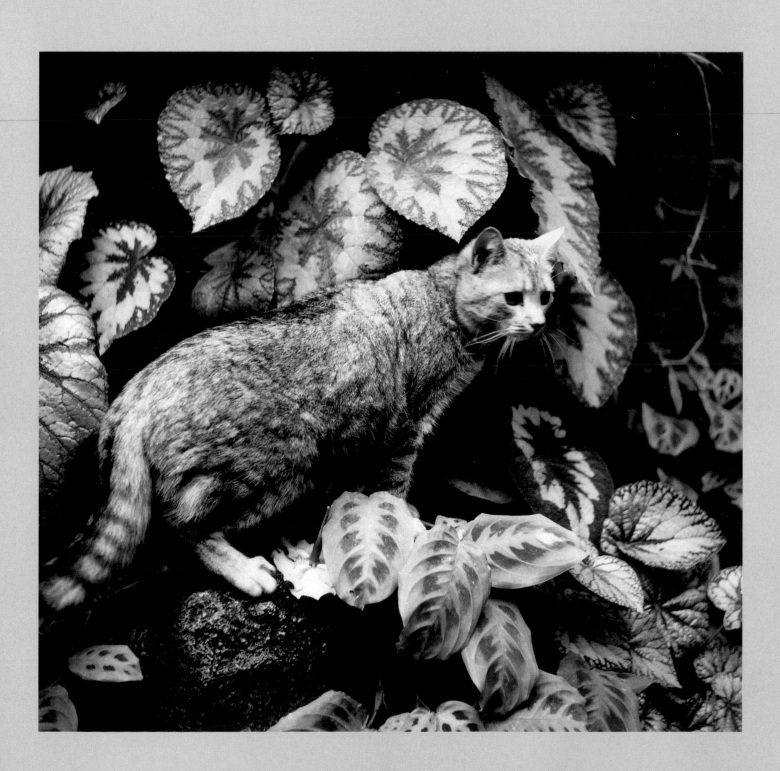

new pets resulted in purring, which was regarded as mystical and even as a means of inducing tranquil sleep. The cats were there to stay!

As the farmers moved into cities, the nature-oriented pantheism of the village shaman evolved into a hierarchy of gods and goddesses, with elaborate rituals governed by a priest class. Claiming a right to rule ordained by the gods, a kingship developed. Divine right evolved into a full god status, with the king becoming Pharaoh, the god-king. Egypt had embraced a theocracy, with the priests supporting the Pharaoh, who had come from their ranks. Since controlling food supplies in urban areas was more difficult than it was in the villages, grain was seized as taxes and stored in royal granaries, easily penetrated by the vermin. These became their breeding grounds.

To combat this plague of rats and mice, the Pharaoh appropriated all of the country's cats, but, even though he was divine, he did not want to risk political problems by depriving his subjects of their beloved pets. So, in one royal act, all the cats in Egypt became demigods, resulting in tens of thousands of four-legged divinities strolling around. Since only a god could own a demigod, the Pharaoh only allowed the populace to house and feed his felines—which had to be brought to a designated granary every night and picked up the next morning—being offered a tax credit for this mandatory service. If a house caught on fire, it was the cats that had to be saved first!

Killing or injuring one of these divine cats was a capital crime, just as removing one of them from the kingdom was considered stealing from the Pharaoh and meant immediate execution. When someone was caught killing a cat, an angry mob would lynch him. If a cat died a normal death, the entire grief-stricken human household mourned the passing with elaborate rituals; chanting, pounding their chests, and often shaving off their eyebrows. The cat was carefully wrapped up in linen and brought to the priests for verification of a natural death, followed by a visit to the embalmers for mummification and burial on temple grounds, with bowls of milk, as well as mummified mice and rats, food, and toys to ease their way into the next world. Elaborate funerals were arranged when the family could afford such extravagance. Cat mummies outnumbered those of people in Egypt; over 300,000 have been unearthed at the tombs of Beni-Hassan.

People believed that the feline divinities could influence their health, fortune, and family. Though the ancient Egyptians worshipped the lion-headed goddess, Sekhmet, the most widely-revered was Bastet—goddess of life and family, sexuality and fertility—who had a cat's head and a sensuous woman's body. There were statues everywhere of the proud cat, wearing golden earrings like a reigning monarch. At a temple dedicated to her at Bubastis, in the Nile Delta, special priests lived permanently, devoted entirely to her. She was usually depicted in a décolleté robe, holding a *sistrum*—a sacred percussion instrument decorated with a cat's head—and a basket. Part of the cat cult was an amulet of the all-seeing sacred eye, the *utchat*, with its magical powers; ubiquitous in decorations and home shrines, guarding the inhabitants from thieves and protecting them from disease. Worn as jewelry, it kept a look out when on the road and protected travelers. It was often depicted as a cat's eye, and the best wedding present was an *utchat* decorated with a mother cat and her litter of kittens to ensure many children.

The Egyptians pampered their purring deities with baths and special grooming, anointing them with fragrant oils and serving them delicious meals. Respected as equals, cats got their fair share of food, even during dire famines. No one would have ever dreamed of eating a cat, as happened in Europe centuries later during periods of famine, when felines were devoured as "roof rabbit." The cat reigned supreme as a symbol among the deities. According to early accounts, the sun-god Ra, the greatest of the gods, appeared as an oversized cat when he fought and defeated darkness, which took on the shape of a serpent.

Most of the breeds developed around the world can be traced back to those first domesticated cats: Egyptian Mau and the Abyssinian. Both reflect their ancestry to the African Wildcat. Egyptian temple paintings reveal both breeds as they appeared during the time of the Pharaohs.

When unloading their wares for Phoenician and other seafaring traders, Nile bargemen, who kept cats on board, would sometimes illegally deliver a few kittens—for a price! The Phoenicians made big business selling their four-legged contraband at exorbitant prices wherever they docked. They even trafficked domesticated cats between Egypt and Greece. From the days of the Pharaohs, sailors kept cats on board their ships as important, functioning crew members in charge of rat control; they were never kept as pets. Reportedly, there were mutinies when a captain kicked a cat.

Thus, domesticated cats slowly reached many Mediterranean ports. Overland caravans crossing the strip of desert separating the Nile from the Red Sea also carried cats. Somehow, their kittens ended up on the dhows of the Indus traders, who took them back to India, whence they were traded eastward to Burma and Siam and northward into China. The surreptitious global colonization of Egyptian domestic cats was underway.

Monks all over Asia soon had cats protecting their prayer scrolls from gnawing rodents. In Siam (now Thailand), the priests bred sacred temple cats similar to today's Siamese, with a tail kink that had a religious significance. The sacred Burmese temple cats—long-haired Siamese with white paws but no tail kink—became the present-day Birman.

Cats throughout the centuries have been pressed into action by mankind for all kinds of feats. In 552 B.C.E., King Cambyses II of Persia used cats in arms to conquer the Egyptian city of Pelouse—without a single lance being thrown! His troops marched on their enemy, with cats held as shields. In fear of wounding their deities, the Egyptians retreated and the city was captured.

During the Persian, Greek, and Roman conquests of Egypt, domestic cats were dispersed over the empires of Darius, Alexander, and Caesar. The Egyptian cats' heritage and nomenclature went with them all over the world. "Cat" in ancient Egypt was *mauw*, the predecessor of "meow." *Cat*, *chat*, *cattus*, *gatus*, *gatous*, *katt*, *katte*, and *kitty* came into modern use. From the name given to the cat goddess in the later period of Ptolemy—Pasht—came *pasht*, *past*, *pushd*, *pusst*, *puss*, and *pussy*.

In the fifth century B.C.E., the Greek historian Herod regaled his fellow countrymen with colorful accounts of feline behavior in the Pharaoh's kingdom. The cat became a status symbol for the rich and a curious rarity offered to loved ones. Artemis, goddess of the moon and the hunt, took a cat's form to defeat the monster Thyphon. The Greeks brought cats to all their Mediterranean colonies, introducing them to Crete, Sicily, southern Italy, and Gaul, via Massilia, which later became Marseille.

When the Romans pushed the Greeks out of Gaul, they introduced domesticated cats picked up during their conquests along the Nile, and soon there were felines all over the country. Cats multiplied and traveled with the troops throughout the Roman Empire. Some Roman legions carried banners emblazoned with the images of cats, symbolizing independence and liberty. They referred to them as *felis*, but later on as *cattus*. In the fifth century C.E., at the decline of the Roman Empire, there were cats as far as Hungary, Sweden, and Denmark.

Egyptian cats came to China from Asia Minor, where they had worked in the silk farm buildings, protecting the cocoons from rodents. In Japan, where it arrived via Manchuria and Korea, the cat was revered for its beauty. In 999 C.E., when five irresistible kittens were born to a pure white cat in the Kyoto imperial palace, Emperor Idi-Jô proclaimed them to be princes, since they had appeared during the holiest period: the tenth day of the fifth moon.

Though silk production became one of the most important Japanese industries from the thirteenth to the fifteenth century, cats, venerated for their ability to predict storms, were allowed to lay around idly while rodents multiplied, posing a major threat in the silk farms. Rather than oblige their pampered pets to return to work, the imperial court commissioned realistic paintings and statues of cats to try and scare the rats, which blithely continued their destructive gnawing. Faced with gigantic economic losses, the emperor ordered all cats to be set free, while forbidding them ever to be sold. Like the emperor and the silk growers, people believed hanging life-sized cat portraits in their homes and temples would have a magical effect and chase away mice and rats.

Respected during their lifetimes, cats were also honored after death by Buddhist priests in the Temple of Go-To-Ku-Ji in Tokyo, which is dedicated to them. Ritualistic cat funerals still draw throngs of mourners, and a vast cemetery in Tokyo has towers of urns for their ashes. But all is not respect and reverence for Japanese cats. It is said there are cats with long forked tails, which are considered evil, capable of becoming demons or taking a human form to bewitch someone. Some felines also pay dearly for the Japanese passion for geishas' music in the Kabuki theater, since their skins are used to make the *shamisen*, a lute-like instrument that the geishas play.

A sign of the times: many of Japan's present-day cat population, which numbers about ten million, are being listened to very carefully. A trendy mini electronic gadget—the Meowlingual—translates their meowing into a language that humans can understand. Over half a million were sold soon after the launch announcement.

Whereas the monks brought their feline companions from Egypt to the other shores of the Red Sea, the Bedouins, having no stored grain, had no need for rat catchers. In fact, they feared the cat because the desert demon, the *ghul* (the origin of the word "ghoul"), was believed to appear in the form of a cat to frighten camels. But when urban areas of Arabia and other countries were Islamized in the seventh and eighth centuries, cats became the companions of pious men and women. Arabic prose contains many references to cats sacrificing themselves for their masters, carrying mysterious concoctions to cure an ailing princess, or simply bringing good luck.

According to legend, once, when Mohammed was called to prayer, he cut off the sleeve of his robe rather than disturb his sleeping pet, Muezza, who was nestled upon it. He is quoted as having said, "Love of cats is part of the faith." Muslims considered the cat to be a clean animal; should a cat drink water from a bowl, the water could still be used for the ablutions before prayers. The pious were convinced that the cat itself performed ablutions, with its purring being compared to the *dhikr*, the rhythmic chanting of the Sufis. A cat, especially a black one, could be used in strange medications. The brain of a wild cat was used to induce abortion. You were safe from enemies if you carried cats' teeth. Throughout the Islamic world, a cat's life was highly valued. In Turkey, even building a mosque could not atone for killing a cat. In Muslim Bengal, eleven pounds of salt—the city's most precious commodity—could be offered as blood money for killing a cat. Elsewhere, the culprit had to heap grain around the dead cat, hung by its tail, until not even the tip of its tail was visible.

For over one thousand years during the early Christian era, hundreds of thousands of cats were persecuted because the Church regarded them as evil demons associated with old pagan religions. Around 1200, the word *Cathar*—designating an anti-clerical enemy, a member of a heretical Christian sect—was erroneously traced to the Latin *cattus*, which undoubtedly explains the association of cats with iconoclasm. In 1223, Pope Gregory IX, in his bull *Vox in Rama*, made the Church's position official in condemning the supposed idol worshipping of the satanic black cat. Europe's feline population was virtually wiped out—with perhaps 10 percent surviving—along with

an untold toll of human lives during the Grand Inquisition. In the Middle Ages, the cat's fate was usually death. It was hunted, sacrificed, tortured, burned alive, or simply killed on sight. Cats, as objects of superstition associated with the devil, believed to possess powers of black magic, and linked to witches, were the incarnation of evil. Ordinary people with cats were often suspected of wickedness and were killed with their pets. On religious holidays, large numbers of cats were burned alive as part of the celebrations.

With the feline population almost completely decimated, plague-carrying rats multiplied and the Black Death spread all over Europe. Interest in killing cats disappeared as humans died in great numbers everywhere. The surviving cats, rapidly multiplying, sought their expanded food source—the rats. Supposedly, the plague ended because so many people had died that crops were not planted, which led the rats to desert the barren fields for the cities, where the increased number of cats to kill the rats stalled the plague's spread. The cats were rewarded as saviors of mankind with a ruthless resumption of the feline inquisition where it had left off. This continued for centuries, until Christian churches stopped focusing on witches and their companions, which were invariably cats.

The Norse goddess Freya, a European cat goddess, incited the Church's preoccupation with cats and witches in the Middle Ages. Her wagon, pulled by two gigantic felines, was perpetually surrounded by cats. Worship, based on cat-oriented rituals, took place on Friday (which means Freya's day). After Christianity barred Freya, she turned into a demon. Friday became the Black Sabbath and the cat became a sign of the devil.

For centuries, witches were linked with black cats. In France, if a witch escaped the flames, witnesses were convinced that she had escaped in the form of a black cat. Every year, thirteen cats, sealed in wicker baskets, were thrown into roaring bonfires to the screaming delight of assembled mobs, which included municipal magistrates, governors, and distinguished citizens. Even the king of France actively took part when he presided over these cat-burning ceremonies at the Place de Grève in Paris. He personally ignited the huge bag of kindling wood under the sack filled with felines. Until 1777, the French city of Metz celebrated the holiday of St. Jean by burning cats.

Neighboring Belgium had its traditional *kattestoet*, in which cats were thrown from a high tower, in the Flemish town of Ypres. The executioner hurled three live cats to their deaths, symbolically averting accusations that the locals practiced pagan idolatry. The poor cats had little chance of surviving, but if one did escape, it was torn apart by the crowd. This fiendish custom, which persisted until 1817, is still remembered today with a joyous folkloric event. The difference today is that the cats being thrown from the tower are merely stuffed toys.

Traces of sadistic and ritualistic cat treatment can be seen throughout history across the globe. Cats were buried in fields as fertilizer or used to conjure up an evil spirit. Fossilized cats were found at the Saint Maclou cloister in Rouen, France, where they had been walled in alive. Sometimes, a cat with a mouse in its mouth was cemented into the foundations of a house. Or, to save a sick fruit tree, a farmer would bury a dead cat among the roots. These practices were common, from Spain to Sweden. A group of mummified cats was even discovered on the grounds of the Tower of London.

French history reveals a long-standing concern for cat symbolism. In the fifth century, after barbarians invaded Gaul, flying banners with black cats representing independence, the first French queen—Clotilde, wife of Clovis—adopted these cats for her royal coat of arms. The word *chat* appeared for the first time in 1175 in a French manuscript. In fact, cat rehabilitation only spread across Europe in the eighteenth century. After King Louis XV imported Angoras and Persians from the Orient for his Versailles Palace, felines became bon ton in France and elsewhere on the Continent. Nowadays, there are almost ten million *chats*, versus around nine million French dogs.

Cats were at the sides of the Portuguese soldiers in Brazil and the Spanish conquistadors in Central America. Cats guarded the food supplies of the Spanish Jesuit missionaries who founded Florida. They arrived in the Canadian New France and were with the French troops when they settled in Louisiana in the eighteenth century. The British also brought cats to the American colonies. The Pilgrim Fathers landed at Plymouth Rock, Massachussetts, with their cats, the ancestors of the American shorthair breed. As the thirteen British colonies developed along the Atlantic coast, an invasion of black rats meant that thousands of cats had to be imported to stop the ravage. When British Crown loyalists sought refuge in Halifax, Canada, they took their cats along. Pioneers who won the West up to the Pacific Ocean were accompanied by their cats as well.

Cat colonies, vestiges of earlier settlements, are still evident in many parts of the world. The cats of Cairo are legendary; so are those of Cyprus, where the monks—who, in 325 C.E., founded the Saint Nicholas monastery on a high promontory—had to bring in cats from Constantinople to get rid of serpents. Though the monastery has long lain in ruins, several hundred progeny of the snake-killers still live there, in what is called the "Cape of Cats." The site of Rome's Torre Argentina, where Brutus stabbed Caesar in 44 B.C.E., is a forum nowadays for hundreds of cats. In St. Petersburg, an elite squad of some fifty felines—unseen by the public—guards the valuable paintings in the Hermitage Museum. These descendants of the cats brought in by Empress Elizabeth Petrovna in 1745 are now fed and fondled by museum staffers as part of their official duties.

In the United Kingdom, "postal cats," hired and paid by the government for over a century, kept rats from nibbling away at the canvas mailbags. Starting in 1868, their weekly salary was one shilling, but rose to one pound with inflation over the years. Unfortunately, their careers ended abruptly with the introduction of plastic mailbags in 1984. They were dismissed from further service and put out on the street—and have remained unemployed ever since. Worst off are the homeless cats of Vietnam, which must continually avoid capture by trendy restaurant chefs anxious to render them into all kinds of sauces.

Even today, cats are still called upon in emergencies to combat rodent invasions. When the Borneo rice fields were infested, hundreds of cats were airlifted from Singapore to save the crops. During dry periods, in some agrarian parts of Cambodia, a caged cat is taken in a procession from house to house so that each villager can spray it; supposedly, its meows of protest are intended to reach Indra, the goddess of rain.

On the more sophisticated side, in our highly technological era, the task of keeping the Austrian Parliament's intricate computer system functioning has gone to the cats. Tired of spending millions of euros to repair cable networks gnawed by rodents, the Assembly's president announced that a feline had been placed in a strategic area to eliminate the problem. The governmental body's electronic contact with the world was thus assured by a small, furry animal.

Even high above the clouds, cats make news. In 2004, a globe-trotting cat named Gin was responsible for causing an SN Brussels Airlines' plane, en route to Vienna, to return to its home base soon after take-off. While its owner slept, the prized four-legged friend escaped from its carrier, wandered down the aisle, and slipped through the cockpit door as a stewardess served lunch to the pilots. The scared animal became "very aggressive and scratched the co-pilot," according to the airline spokesman. Fearing damage to sensitive flight equipment and more feline terror, the pilot turned back to Brussels. Do cats like Gin earn air miles when they circle the globe?

Many superstitions still persist today. The belief that "a black cat crossing your path brings bad luck" goes back to the Salem witch hunts in Colonial America, when women suspected of witchcraft were swiftly condemned and hanged along with their cats. Ironically, that superstition was distorted from the British belief that "black cats crossing your path bring good luck." A present day holdover from medieval persecution is Halloween, with cats and witches forming an integral part of the celebrations.

Probably the most bizarre use of cats was during the Cold War, when the Central Intelligence Agency in Washington experimented for five years with a feline as a secret espionage agent, equipped with microphones and transmitters. Unfortunately, before the four-legged spy could be dropped in the Kremlin, he was killed by a taxi.

Another mishap occurred in Vietnam in 1968, when specially trained cats were taken to guide troops during night patrols, since their vision was seven times that of the soldiers. But the animals went AWOL—taking off as soon as they were set free in the jungle.

Aside from combat missions, American cats are now undergoing medical investigations. A cat named Cinnamon is at the center of a scientific experiment concerning the genome of the domestic cat. Coming from a specially bred colony at the University of Missouri, her lineage can be traced back several decades. Researchers of the $5.5 million Cat Genome Project are studying her DNA, hoping to unlock information to the benefit of mankind.

On the lighter but ethically questionable side, a Texan paid 39,000 euros (about $50,000) for her cat, Nicky, to be cloned—the first such operation in the U.S.—by the Californian Genetics Savings and Clone Company. The delighted owner proclaimed that her "little Nicky" was identical to the original in personality and looks, right down to its whiskers. After that successful duplication, five more cats were booked for cloning, along with the first dog. Today, notwithstanding the cloned cats joining the American feline population, there are about seventy million cats in the U.S.

Every continent in the world, except Antarctica, counts cats among its inhabitants. The global total is estimated at about four hundred million—and growing every day. There are now over fifty distinct cat breeds.

DAILY LIFE

THAT CATS RULE THE HOUSE IS WELL KNOWN. THE INTIMATE LIFE OF CATS
AT HOME HAS ALWAYS BEEN AN INSPIRATION FOR PHOTOGRAPHERS,
FROM THE MASTERS OF YESTERYEAR TO THE BIG NAMES OF TODAY. CURLED
UP IN THE ARMS OF A CHILD, DOZING NEXT TO A LANGUOROUS NUDE,
GAZING WONDERINGLY AT THEIR OWN REFLECTION IN THE MIRROR,
THEY ARE THE EPITOME OF ELEGANCE. PERCHING PRECARIOUSLY ON
A ROOFTOP, GRAVELY REGARDING THE CAMERA FROM INSIDE A FLOWERPOT,
OR HANGING FROM THE DRAPES, THEIR HUMOROUS, TOUCHING,
AFFECTIONATE ANTICS ARE THE SOURCE OF MANY A FASCINATING PHOTO.

HENRI CARTIER-BRESSON, *Our Cat Ulysses and Martine's Shadow*, Paris, 1989

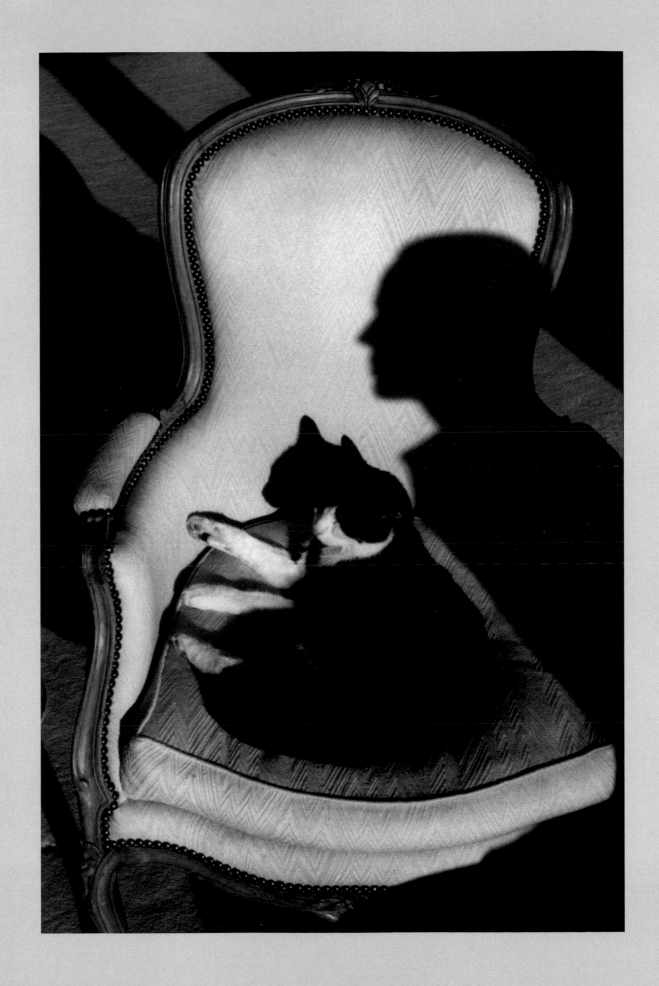

JACQUES-HENRI LARTIGUE, *The Twins*, Paris, 1908
From the age of six in 1900 until his death at ninety-two in 1986, Lartigue produced some one hundred albums containing 14,423 pages
of photos, which amounted to a lifelong diary. In 1904, he began experimenting with motion by recording his brothers, cousins—and a cat—
leaping into the air. He recorded his pampered childhood in a prosperous family, the advent of cars and planes, beautiful women in
the Bois de Boulogne, society and sporting events. Although he occasionally sold his pictures to the press or exhibited his photos,
he only became well-known in France and abroad when, at the age of sixty-nine, he was discovered by a curator at the Museum of Modern
Art in New York, who organized a major retrospective. Today, Lartigue is considered as one of the twentieth century's most innovative
and important photographers.

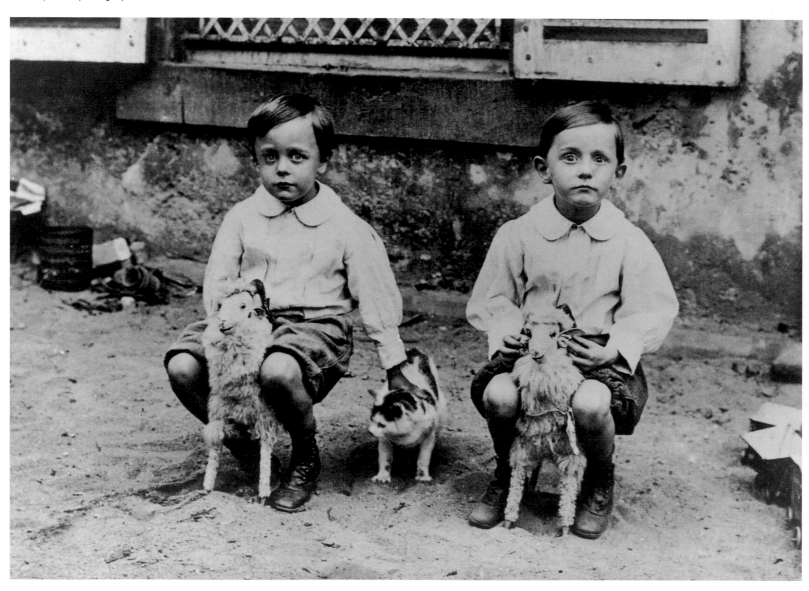

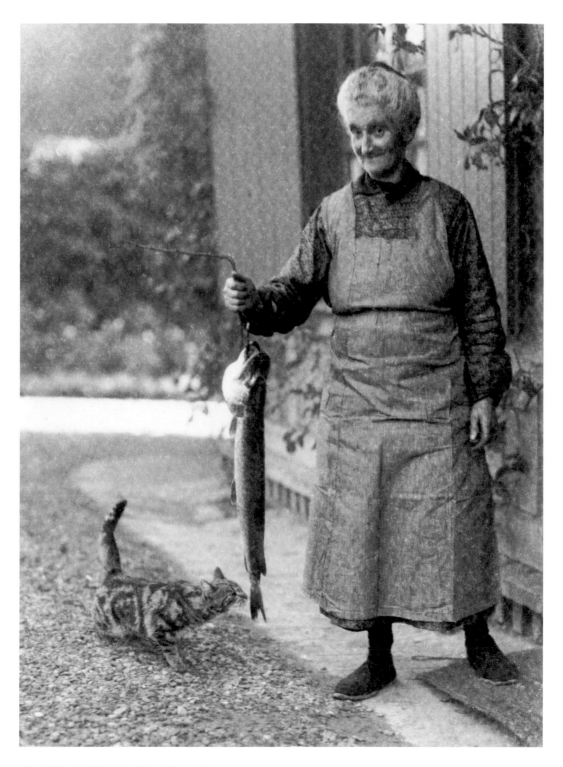

CHARLES AUGUSTIN LHERMITTE, c. 1912

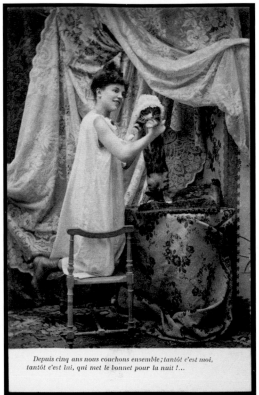

*Depuis cinq ans nous couchons ensemble; tantôt c'est moi,
tantôt c'est lui, qui met le bonnet pour la nuit !...*

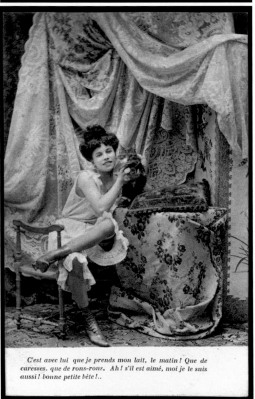

*C'est avec lui que je prends mon lait, le matin ! Que de
caresses. que de rons-rons. Ah ! s'il est aimé, moi je le suis
aussi ! bonne petite bête !..*

Left: A popular series of turn-of-the-century postcards by anonymous photographers, featuring attractive damsels cuddling cats with saucy texts like: "We have been sleeping together for five years. Sometimes it's me, otherwise it's he who wears the bonnet through the night."

Facing page: EDWARD STEICHEN, *Camera Work*, 1903
Edward Steichen, the American photographer and curator who lived from 1879 to 1973, is unquestionably one of the most influential and notable figures in twentieth century photography. In 1902, he became a founding member of the Photo-Secession movement, named after a similar movement in Germany: an avant-garde group of photographers, led by Alfred Stieglitz, revolting against the established approach to photography, which they considered too academic. He designed the cover of their publication, *Camera Work*, which would frequently reproduce his work in the years to follow. As director of the Department of Photography at the Museum of Modern Art, New York, from 1947 to 1962, Steichen organized some fifty shows. Among them was the groundbreaking *Family of Man*, for which he selected images from over two million photographs, and which became the most popular exhibition in the history of photography.

His widow, Joanna Steichen, commented: "Though I believe there were cats around in Voulangis, the French village where he lived, and later at the family farm, Umpawaugh, in Connecticut, Steichen did not really relate to cats. He was definitely a dog person, preferably Irish Wolfhounds. However, he found cats aesthetically fascinating and had a bronze copy of a famous Egyptian cat in his studio for many years. So, the cat portrait (see p. 46) and the nude with a cat (facing page) were aesthetic studies more than an interest in the animal itself. I'm sure he wanted us to see that the woman's pose had the flexibility of the cat."

ÉDOUARD BOUBAT, Oregon, U.S., 1976
Édouard Boubat is internationally reputed for his sensitive recording of daily life in his native Paris, as well as for the unique, elegant photos
he took while traveling all over the world as a permanent contributor to *Réalités* magazine, founded in the forties. He was an important French
humanist photographer, along with Cartier-Bresson, Kertész, Doisneau, and others. His photographer son, Bernard, recalled, "My father
loved cats and they were always part of the household. He took many pictures of them at home or wherever a special cat caught his eye.
He even wrote poetic odes to them, which are included in his eight hundred-page monograph, along with a number of his cat photos."

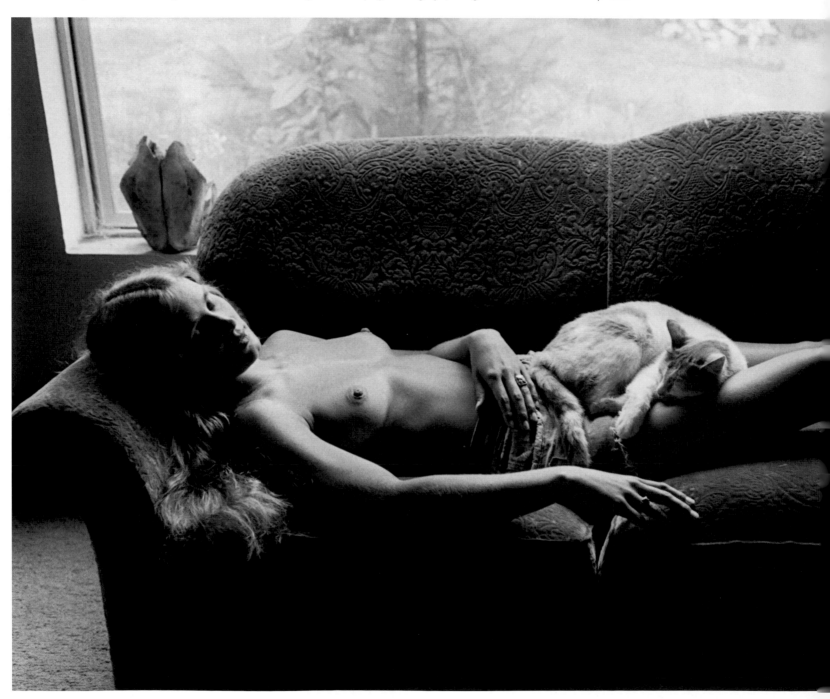

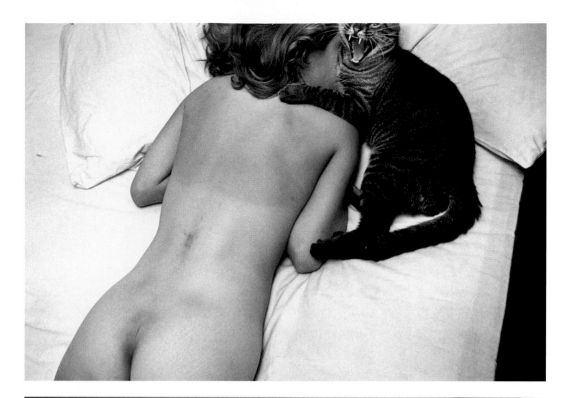

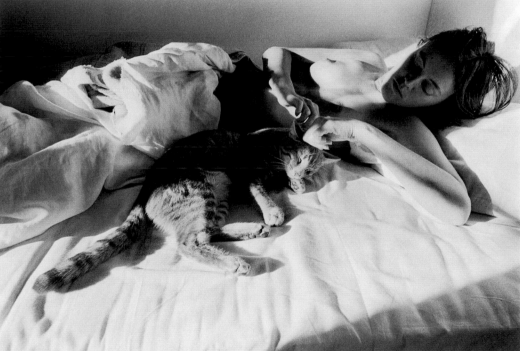

Top: ELLIOT ERWITT, New York, 1954

Bottom: BRUNO REQUILLART, Paris, 1972–73
Bruno Requillart—photographer of Maurice Bejart ballets; the tumultuous times of the seventies; parks and war memorials; and a series on the urban environment, particularly of Paris—gave up photography in 1979 to return to painting. In the last five years, he has picked up his camera again to record the Paris of today, the city of "old Europe," a century after Atget. "The cat in the photo, named Berlioz, was left for me to take care of. I have two cats now: Boogie and Woogie. They are totally aware of how they pose—always with style. It's the cat who decides the photo; the photographer could be blind and the result would still be good."

29

MARC RIBOUD, Prague, 1977
"The Prague photo was the first time that I photographed a cat beside a nude. I must say that it was not the woman who attracted the cat, nor my presence, but the heat of the fireplace, which warmed up the cat's belly. I've always been prudish about nudity. That's why this undressed young Prague woman was glimpsed in a cracked mirror. I preferred to keep my distance....

Do I dare say that I don't like cats very much? But in fact, what's there not to like about cats? They are beautiful, don't make noise, don't harm anyone. The film maker Chris Marter canonized the cat with a saintly reflection: 'God created man to take care of cats.' Sometimes, a cat sweetly and quietly appears within the range of my lens, without seeking authorization. If he knew how to write, he would surely demand the animal's rights over his image."

JEAN-PHILIPPE CHARBONNIER, *Springtime Sunday*, 1970

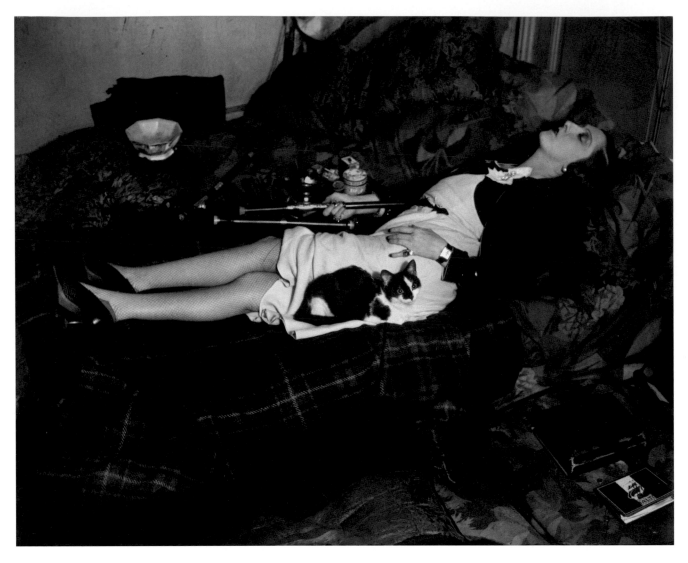

Above: BRASSAÏ, *A Sleeping Opium Addict*, 1931
Brassaï, born Gyula Halász, took his name from his birthplace, Brasso—at the time in Hungary (now Brasov,
Romania) and famous for being the home of Count Dracula. In the early thirties, he began a series of photographs
of the seamier side of Paris night life; a fascinating collection of prostitutes, pimps, madams, transvestites,
and pleasure seekers. Sometimes brilliantly lit, but more often dark and merciless, these photos were published
in 1933 in a book entitled *Paris by Night*. Brassaï's reputation was established and the book is now a classic.

Facing page: WEEGEE, *Heat Spell, New York City Rooftop*, 1941
Weegee, whose real name was Arthur Fellig, took his pseudonym from the spiritualist Ouija board. As a news
photographer, he bragged he had "powers" to be the first at fires, murders, and accidents. In fact, he slept
with his clothes on, had his camera equipment in the trunk of his car and a police radio next to his bed.
A New York character, he was brash, direct, and just went in there and got the picture, no matter how horrific.
He was called "the living flashgun man," pushing his way through crowds to blast the scene of some crime
or emergency with this great flash of light. Weegee incarnated the Hollywood stereotype of the news photographer.

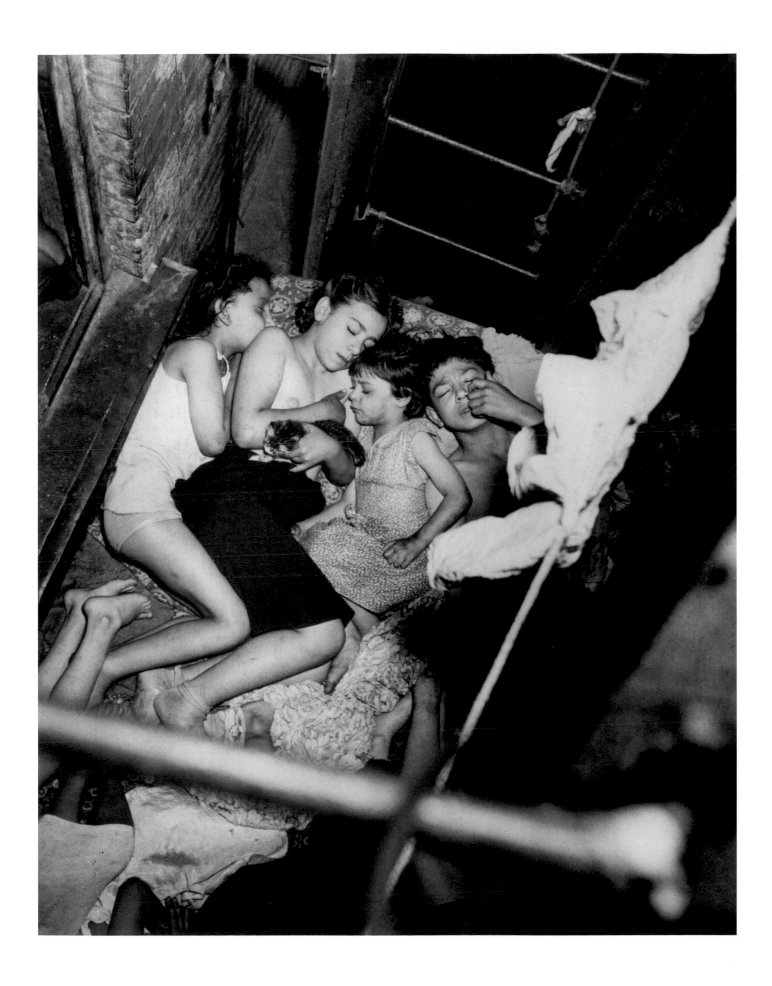

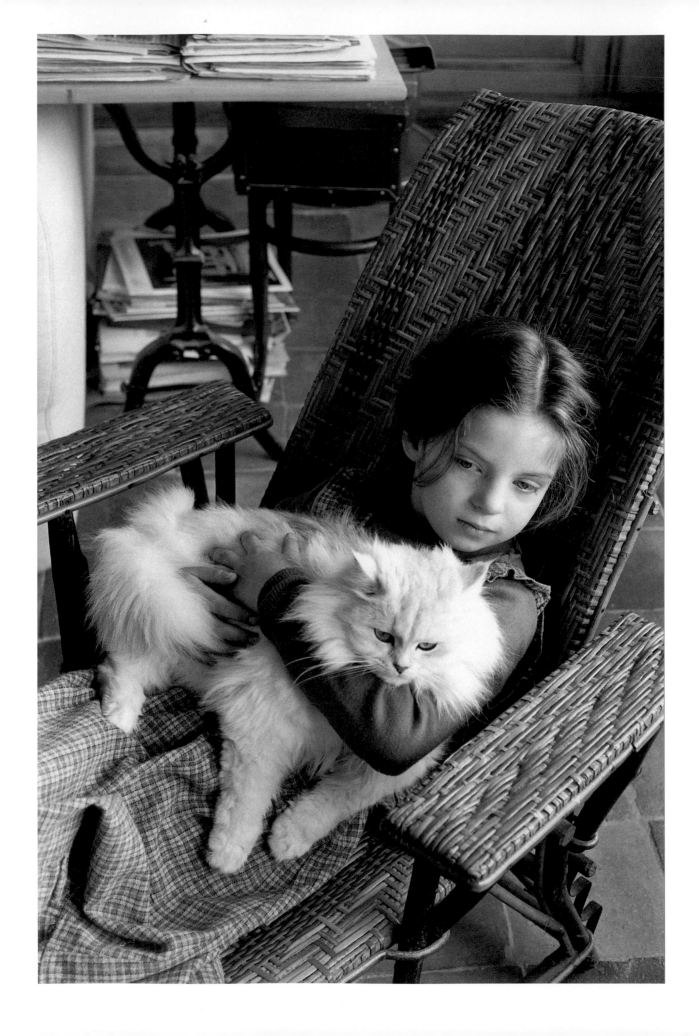

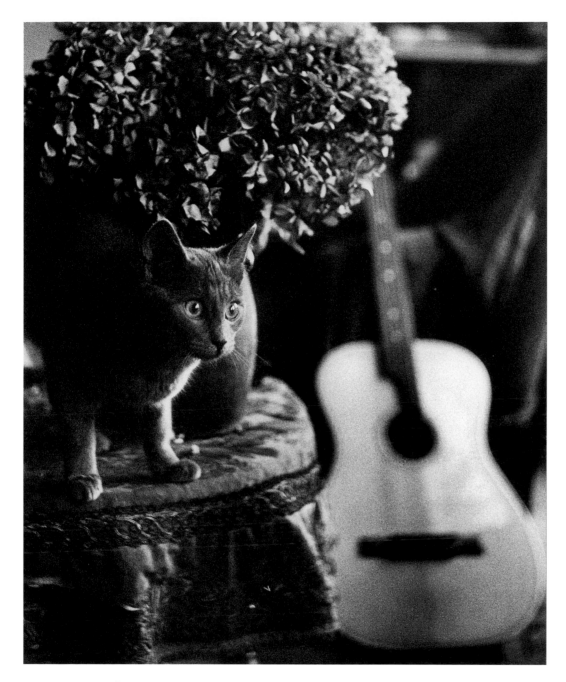

Above: JANINE NIÉPCE, Paris, 1952

Facing page: HENRI CARTIER-BRESSON, *Daughter Melanie*, Paris, 1978
Henri Cartier-Bresson—the late master of the "decisive moment," which he himself defined as the key to his
work—had the well-deserved admiration of his French compatriots, who referred to him as "*l'œil du siecle*"
("the eye of the century"). Most of the twentieth century paraded before his magical Leica—the grand events
and the small details of everyday life. "Photographing," he once said, "is to put your brain, your eye,
and your heart in the same line of sight. It's a way of life." According to Martine Franck, his widow, "The cat
photographed by H.C.B. at home, called Ulysse, was a stray he had found." He photographed this cat
in the intimacy of his home with his young daughter and his wife on many occasions. Other of his feline photos
reflect his well-known sense of humor.

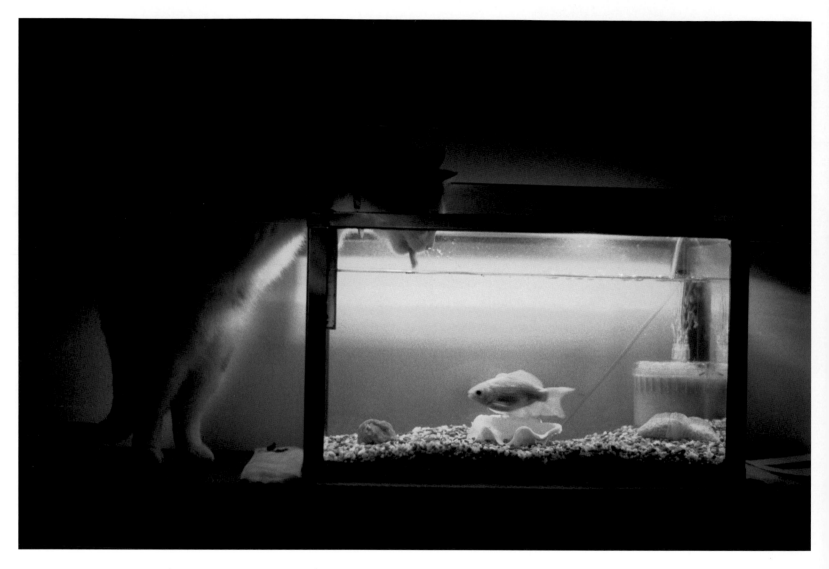

JK/MAGNUM PHOTOS, Los Angeles, 1984

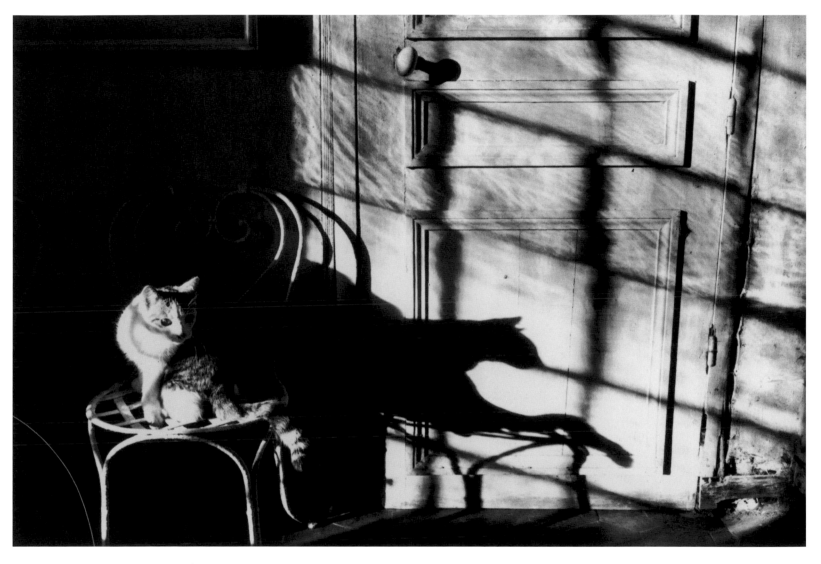

PIERRE BÉRENGER, Vaux le Pénil, France, 1973
Demonstrating a genuine love of animals, Pierre Bérenger has extensively photographed zoos, as well as
free-roaming dogs, cats, and other domesticated pets. Bérenger recalled a very special cat photograph:
"I was visiting an artist to take her portrait. Her pets—one dog and three cats—followed me everywhere I went.
In the splendid light flooding into her house, one cat in particular, perched on a chair and intrigued by its
own shadow cast on the wall, played with the changing shape for quite a while. I was able to capture that
strange and magical image of a feline fleeing its own seated self." On the personal side: "All my life, I've had
cats, mostly living in the garden. Cats are magnificent animals. By sharing their lives, I retain visions of tenderness,
voluptuous grace and, above all, joy and happiness."

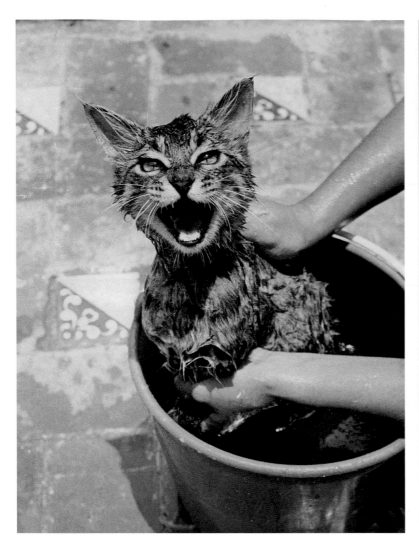 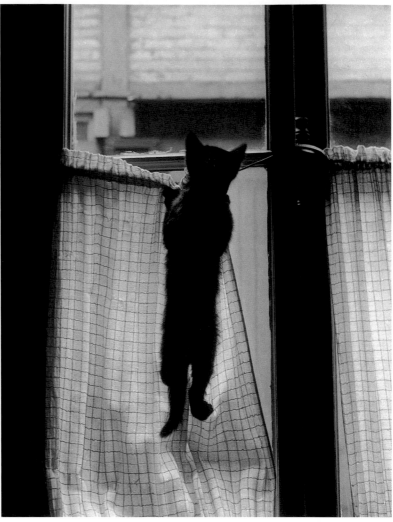

Above: FRANCIS STOPPELMAN, Mexico City

Above, right: WILLY RONIS, *At Home*, Paris, 1954
Willy Ronis, born in Paris in 1910, was the first French photographer to exhibit at the Museum of Modern Art in New York. "I was never in pursuit of the strange, never saw the extraordinary, but rather what is most typical of our daily existence, in whatever place I found myself; a sincere and passionate quest for the modest beauty of ordinary life," explained Ronis. He has taken many shots of cats in his long and illustrious career, "being seduced by their grace, beauty, and kindness. But frankly, since the arrival of the first cat in our house in 1946—a pet for my six-year-old son—and a succession of other cats since then, I have never really grown attached to them."

Facing page: BRASSAÏ, c. 1946
THE FRENCH HUMANISTS: Brassaï, Henri Cartier-Bresson, and André Kertész were at the forefront of poetic realism in the influential French humanist movement, which flourished in the mid-twentieth century from 1930 to 1960, a reaction to the horrors and devastation of two world wars. The 1930s marked a move toward a realism focused on man, rather than on experimental technique and style—fashionable at the time—giving the French humanist movement a unique place in the history of photography. Profoundly shaken by the brutality of the wars, humanist photographers wanted to believe in the idealism and inherent goodness of man. Willy Ronis, Janine Niépce, Sabine Weiss, Jean-Philippe Charbonnier, Jean Dieuzaide, Édouard Boubat, and Robert Doisneau, among others, all created humanistic images.

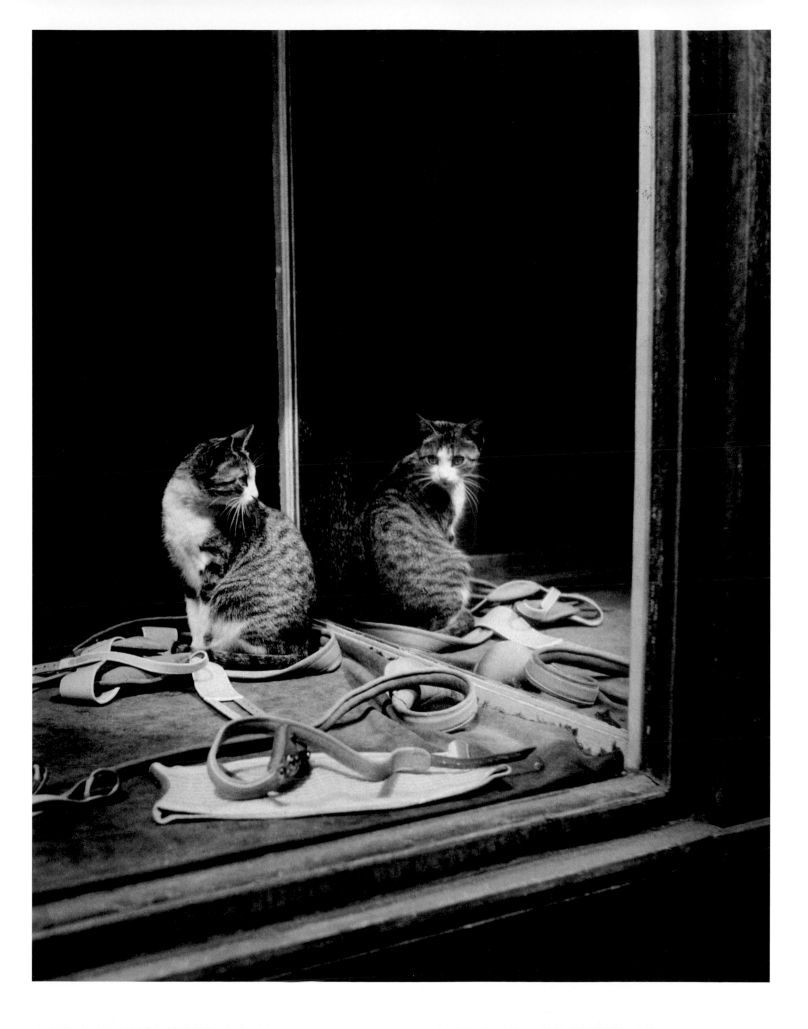

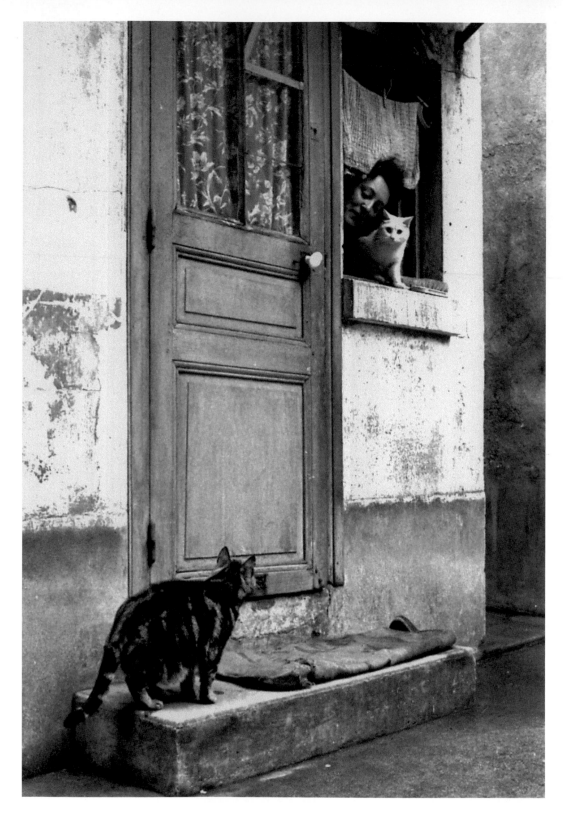

SABINE WEISS, Paris, 1953

Her compassionate curiosity and her talent for getting total strangers to share the intimacy of their daily life prompted Edward Steichen to include Sabine Weiss in his renowned exhibition, *The Family of Man*, in 1955, at the Museum of Modern Art in New York. "In photography, my objective is not to search for a predefined image, but rather to be a witness of a passing instant of life, and to freeze this moment." "The cat has always occupied a special place in my life," recounted Weiss. "The cat is fleeting and nonchalant, which touches me. He shares with me this taste for life and the ephemeral moments which I love to photograph."

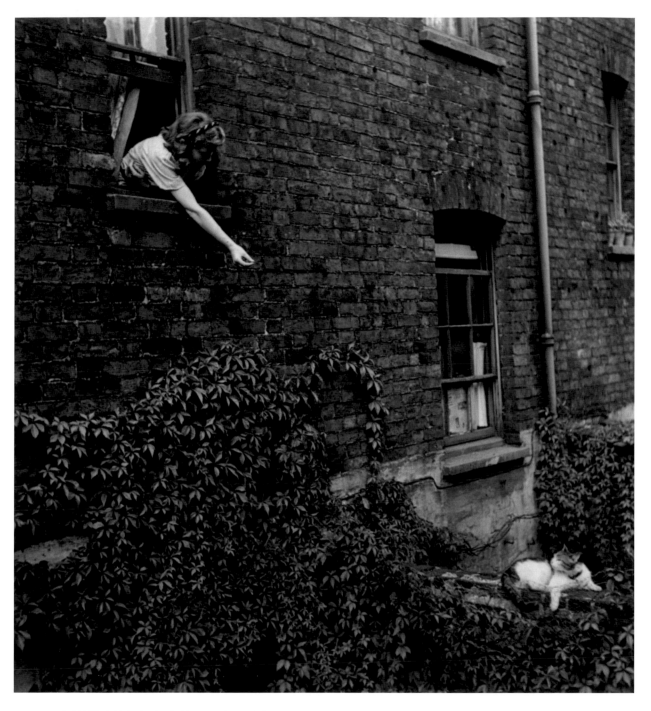

ROBERT CAPA, *At the Gibbs'*, London, 1941
Andrei Friedmann invented the name Robert Capa—a fictive American photographer—when he moved from
his native Budapest to Paris and began a small photo agency with his German fiancée, Gerda. He was the war
photographer *par excellence*. During the Spanish Civil War, his picture of a dying soldier brought him overnight
fame. During World War II, he famously photographed the beaches of Omaha, as well as the invasion of North
Africa and Sicily. He once commented, "To me, war is like an aging actress—more and more dangerous and
less and less photogenic." When, in 1954, *Life* magazine needed a photographer in Indochina, they sent
Capa. But it proved one war too many. He stepped on a land mine and was killed instantly, camera still in hand.

Above: YLLA, New York, c. 1951

Facing page: ÉDOUARD GOLBIN, House of Prosper Mérimée, Paris, 1984
Édouard Golbin, born in Chile but of French origin, started off as a photographer for a major Argentinean advertising agency. Upon his return to France, he specialized in photographing industrial sites. "Seeking shapes, shadows, and highlights, revealing the essential situated somewhere between what is hidden and what is apparent, is what draws me to black-and-white photography," he explained. He searches for cats and dogs in Parisian streets, and has photographed hundreds of them. He commented, "Cats are observers, dogs are actors." Describing the very special moment recorded in this shot, he recalled: "I spotted a cat high up, standing with its paws against the railing of a balcony, checking out life on the outside. I was able to immortalize that curious cat living in the house of Prosper Mérimée, a renowned cat lover and the author of the novel *Carmen*."

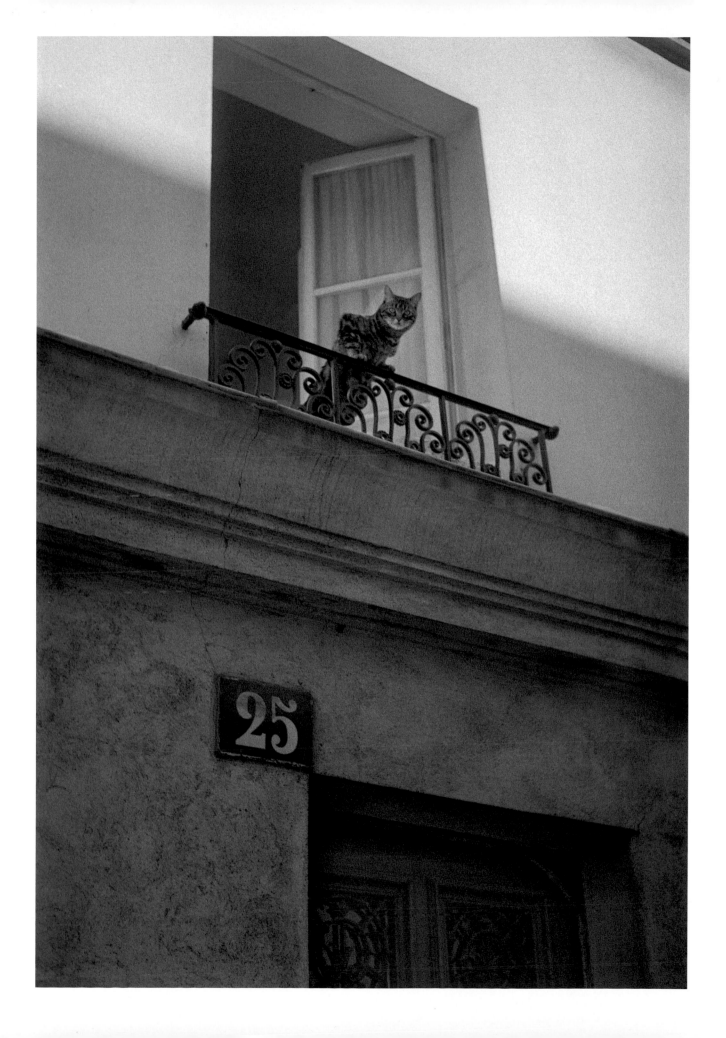

IN FOCUS

INNATELY GRACEFUL, DECORATIVE, AND ULTIMATELY PHOTOGENIC, CATS
LOVE TO PREEN FOR THE CAMERA LENS. BUT THEY ARE ALSO INDEPENDENT,
ALL TOO AWARE OF BEING DESIRED OBJECTS OF ADMIRATION, AND
CONDESCEND HAUGHTILY TO BEING PHOTOGRAPHED. PORTRAYED
BY WELL-KNOWN PHOTOGRAPHERS WORLDWIDE, SUCH AS MAN RAY,
LÁSZLÓ MOHOLY-NAGY, DAVID DOUGLAS DUNCAN, EDWARD STEICHEN,
THOMAS EAKINS, HANS SILVESTER, YANN ARTHUS-BERTRAND, AND
SIR CECIL BEATON, CATS NATURALLY SEEM TO KNOW HOW TO POSE,
EVOKING MYSTERY, PLAYFULNESS, TEASING, AND IRRESISTIBLE CUTENESS.

YANN ARTHUS-BERTRAND, Les Mesnuls, France, 1993

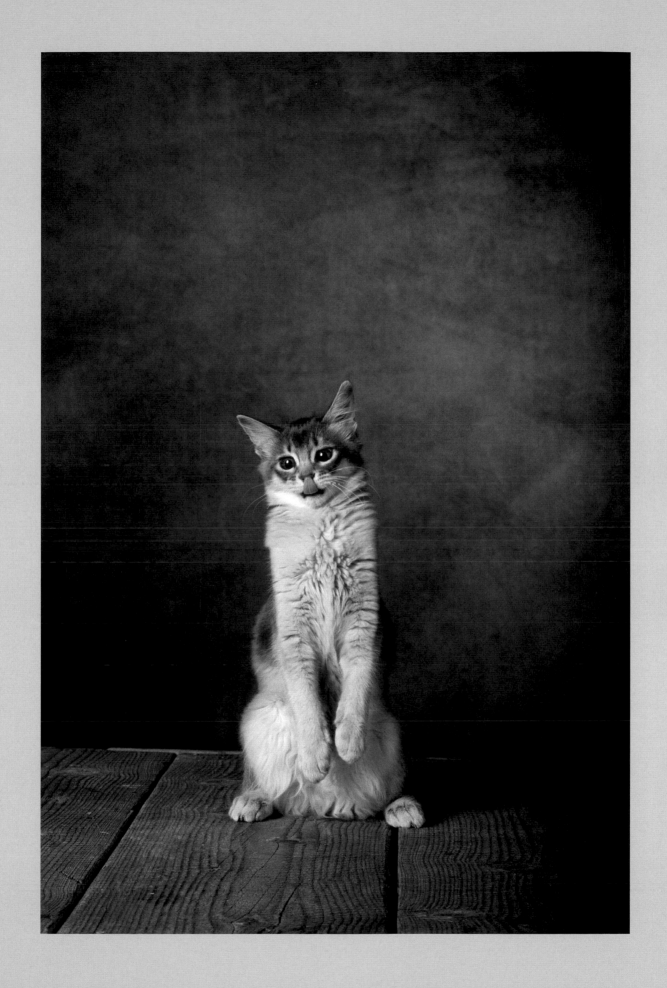

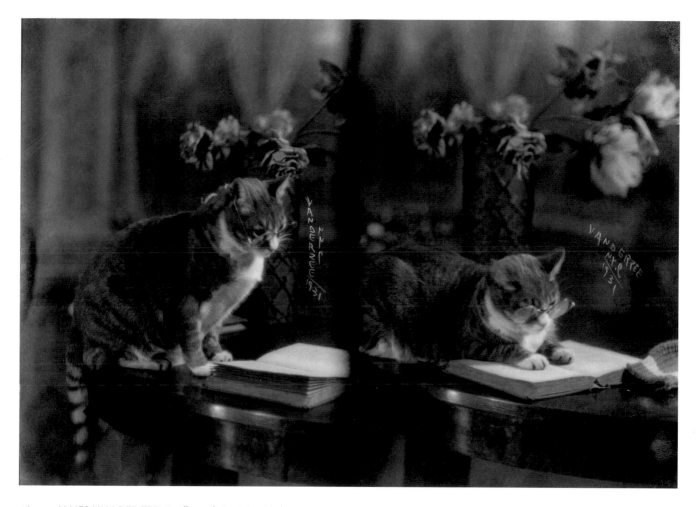

Above: JAMES VAN DER ZEE, *Intellectual Cat*, New York, 1931
James Van Der Zee, whose portraits of black New Yorkers chronicled the Harlem Renaissance of the twenties,
was a prominent photographer until after World War II, when he found himself forgotten and nearly destitute.
By chance, a Metropolitan Museum of Art curator came across his archived prints and negatives in 1967,
resulting in the museum's momentous exhibition, *Harlem on My Mind*, two years later. Rediscovered,
he remained an important figure in the world of photography until his death in 1983, at the age of ninety-six.
"James had cats," recalled his widow, Donna. "He took pictures of them at home, and they were often part
of the portraits he took of artists and other celebrities who came here to be photographed."

Facing page: EDWARD STEICHEN, *The Cat*, 1902

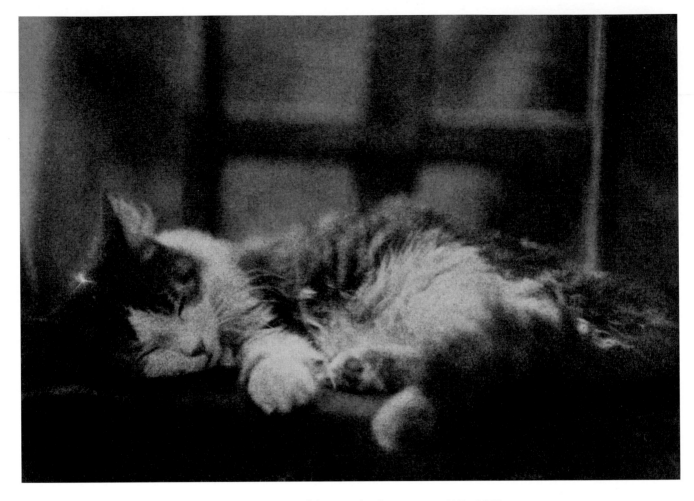

Above: CHARLES HUGO, *La Chatte Mouche (Minette)*, one of the Hugo family cats, Jersey, U.K., 1853 (probably in collaboration with Auguste Vacquerie)

Facing page: FRANK EUGENE, France, 1916

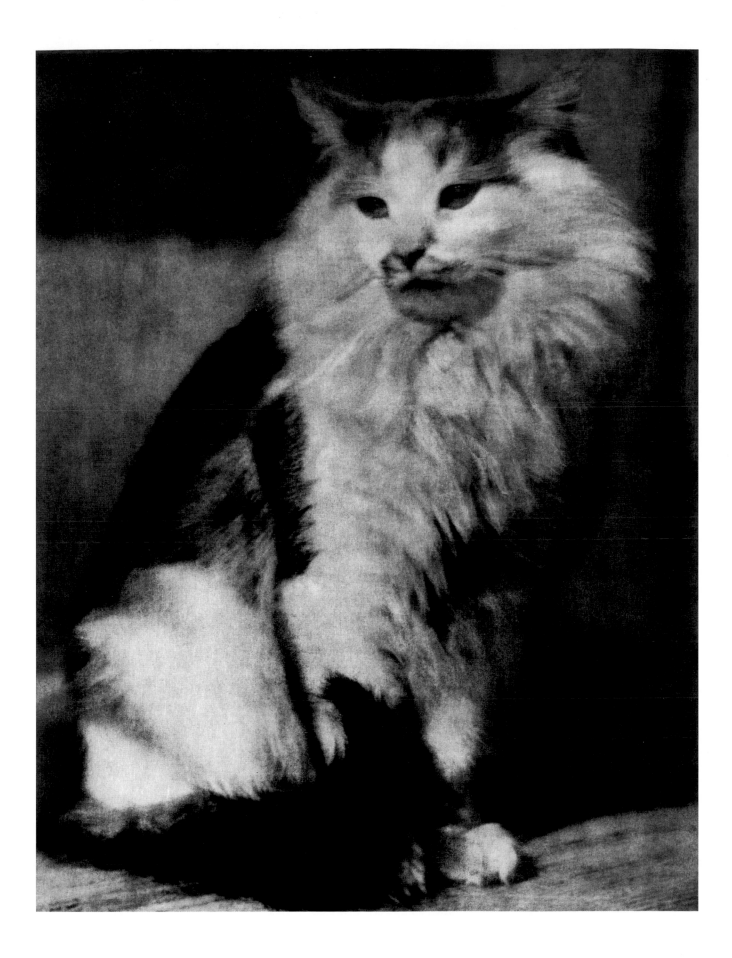

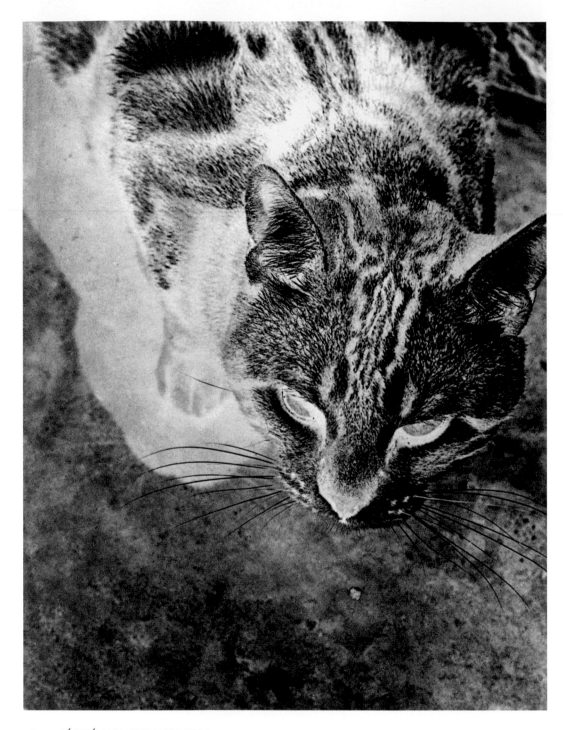

Above: LÁSZLÓ MOHOLY-NAGY, 1926
As a major proponent of the avant-garde theories of the Bauhaus in the twenties, László Moholy-Nagy experimented with all kinds of photographic technologies and effects. Ever the innovator, he was also involved in filmmaking, typography, design, sculpture, and teaching. Among his most memorable photos is this one of his own cat, composed of a close-up conventionally printed, paired with a silver negative print, which exactly reversed the lighting effects.

Facing page: WANDA WULZ, *Me and My Cat*, Trieste, Italy, 1932
After Wanda Wulz joined the Italian Futurist Movement in 1931, she became known for her avant-garde portraits, still-life compositions, and photo montages, which were widely exhibited. One of her best-known works resulted from her superimposing a photo of her cat on a portrait of her own face.

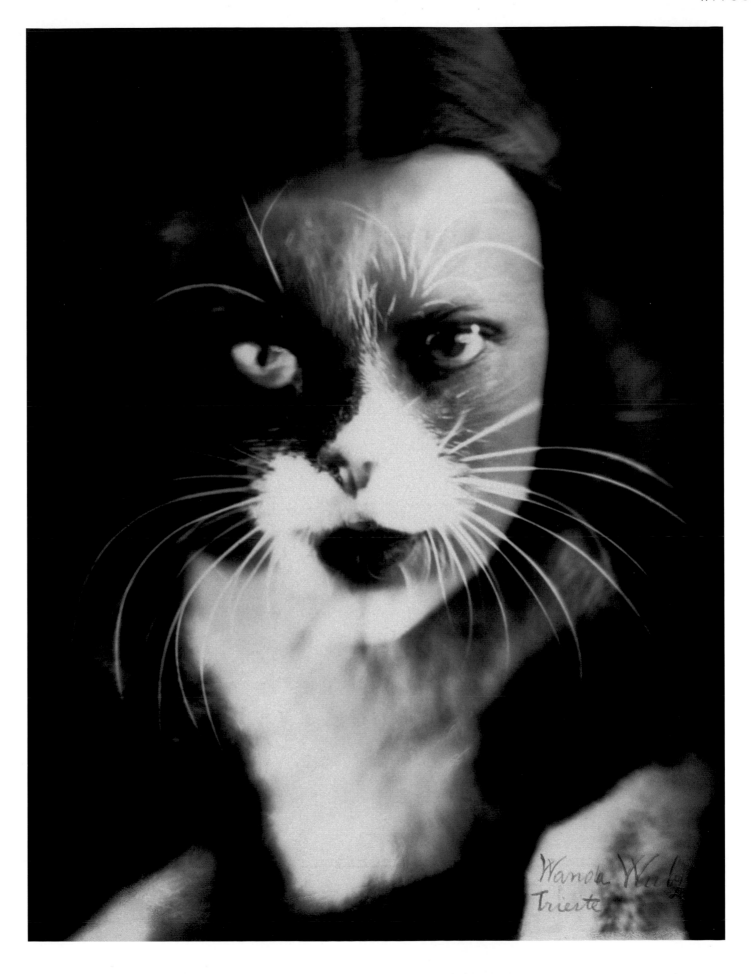

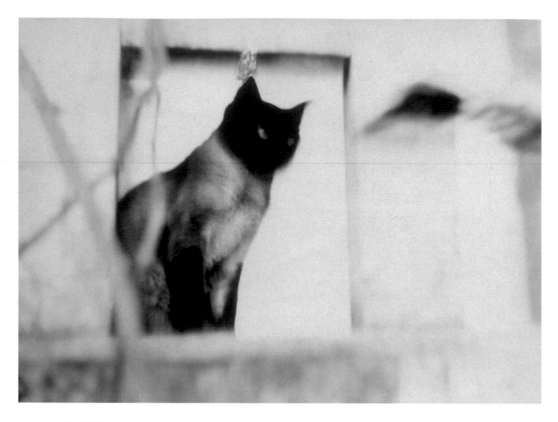

Above: MAN RAY, 1922

Facing page: ARIANE, Provence, 2000

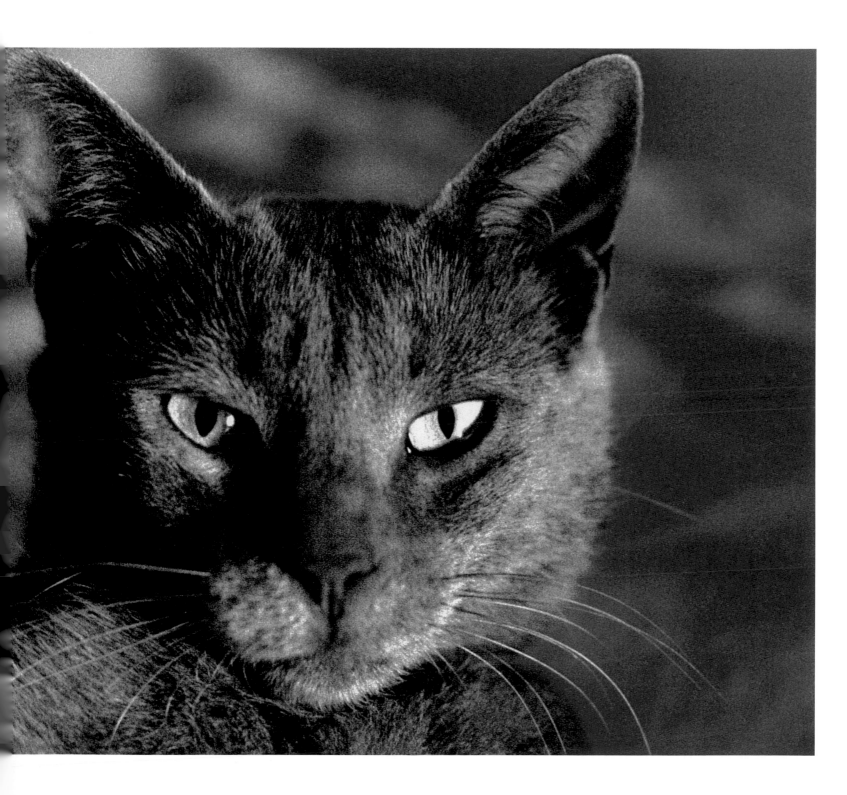

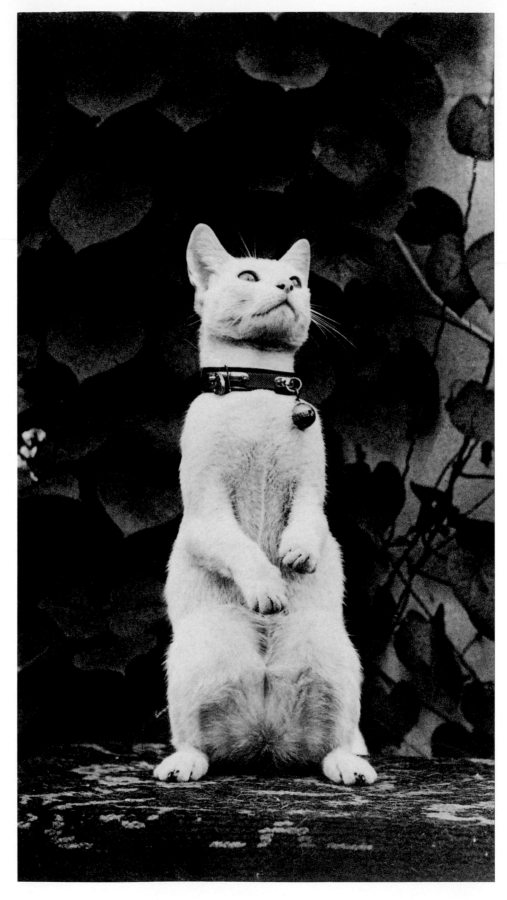

THOMAS EAKINS, *Cat in My Garden*, U.S., c. 1880–90

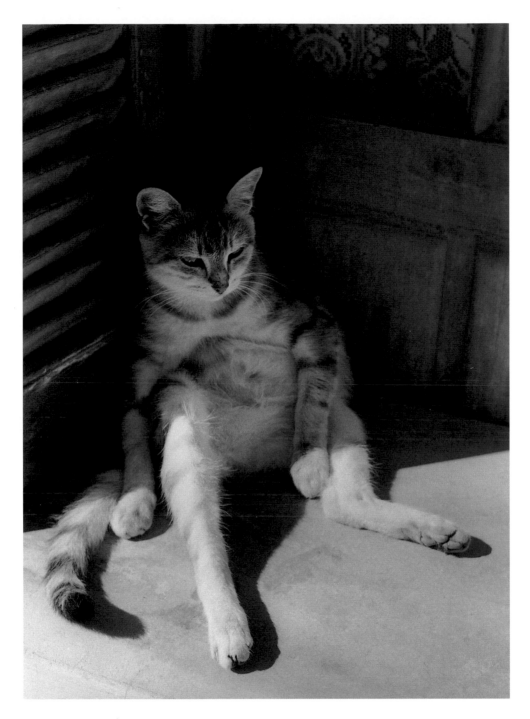

DENIS BRIHAT, Antibes, France, 1953

Denis Brihat moved to the Luberon, in the heart of Provence, almost fifty years ago to devote himself to researching nature and developing techniques for the metallic toning of photos. On the subject of cats and photographing them, he said: "Bébert (the namesake of the French author Céline's famous cat) is our pet, and hopefully will not be devoured by a fox as so often happens in our region. It's a good cat, not so tender and rather wild. He eats biscuits, but prefers birds. I wonder if he is not a spy, since he reads my mail and lies on all my photos. In the darkroom, he sniffs the strange solutions I prepare and drinks the running water, although he refuses to drink from a bowl. I feel that man is the domesticated animal of the cat. Generally, cats fascinate me, and that's why I have taken so many cat photos—for my own pleasure."

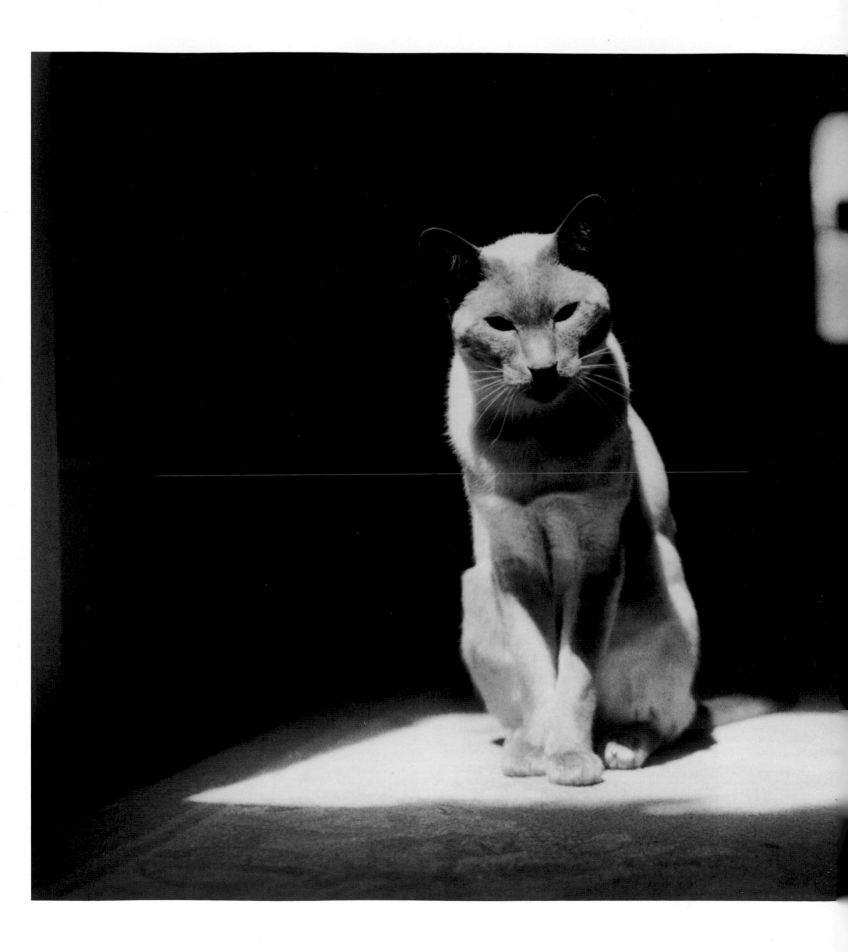

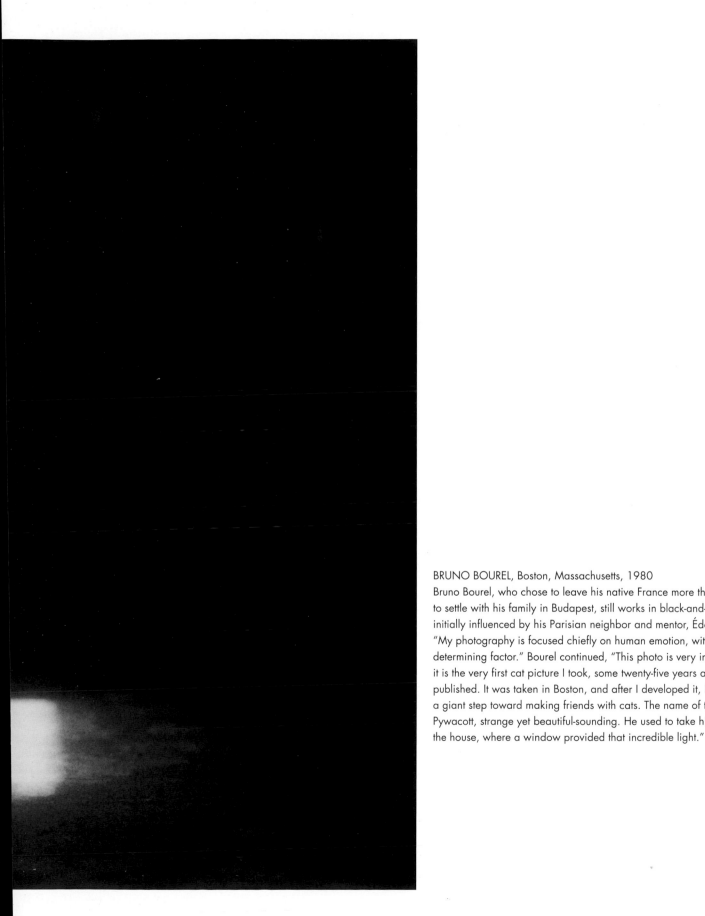

BRUNO BOUREL, Boston, Massachusetts, 1980

Bruno Bourel, who chose to leave his native France more than a decade ago to settle with his family in Budapest, still works in black-and-white and was initially influenced by his Parisian neighbor and mentor, Édouard Boubat. "My photography is focused chiefly on human emotion, with light as the determining factor." Bourel continued, "This photo is very important for me because it is the very first cat picture I took, some twenty-five years ago, but it was never published. It was taken in Boston, and after I developed it, I knew I had made a giant step toward making friends with cats. The name of this Siamese was Pywacott, strange yet beautiful-sounding. He used to take his naps on top of the house, where a window provided that incredible light."

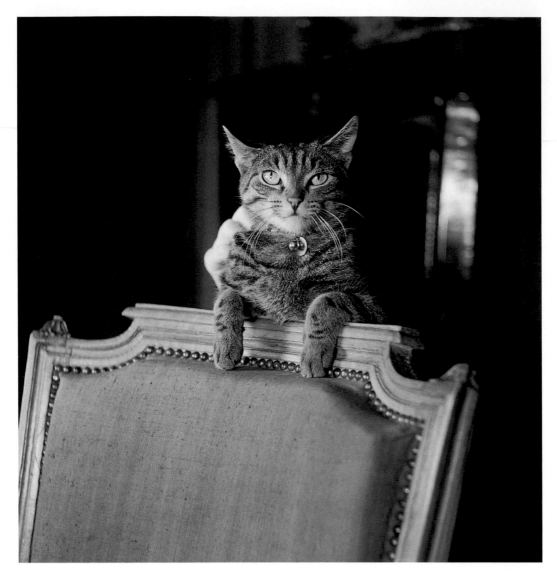

Above: ROBERT DOISNEAU, 1951

Robert Doisneau captured the streets and atmosphere of Paris as the city entered the modern era. Best known for his photo *The Kiss* (*Le Baiser de l'Hotel de Ville*), he is a key figure in the history of documentary photography. As a member of the humanist group in the forties and fifties, he photographed ordinary life around him, that which presented itself by chance. He regarded his life's work as "a surrealist project, a little theater" of the worlds he passed through. He remarked in 1991, "The flower that grows between the railway tracks is infinitely more interesting than flowers in vases."

Facing page: FERNANDO SCIANA, Santa Margherita, Liguria, Italy, 1993

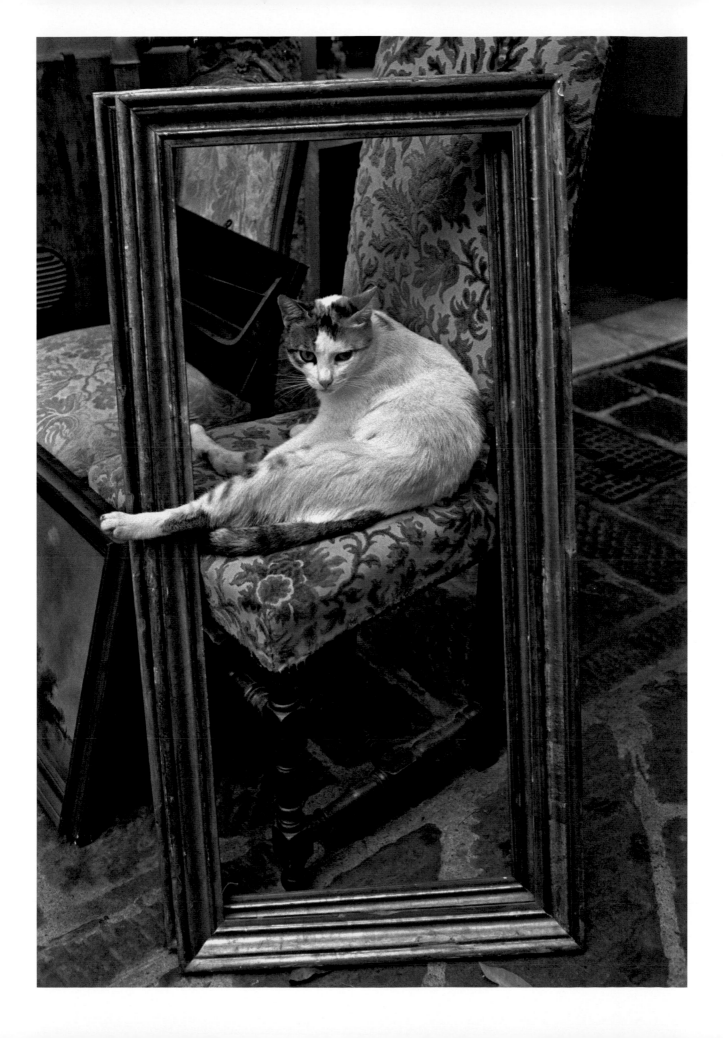

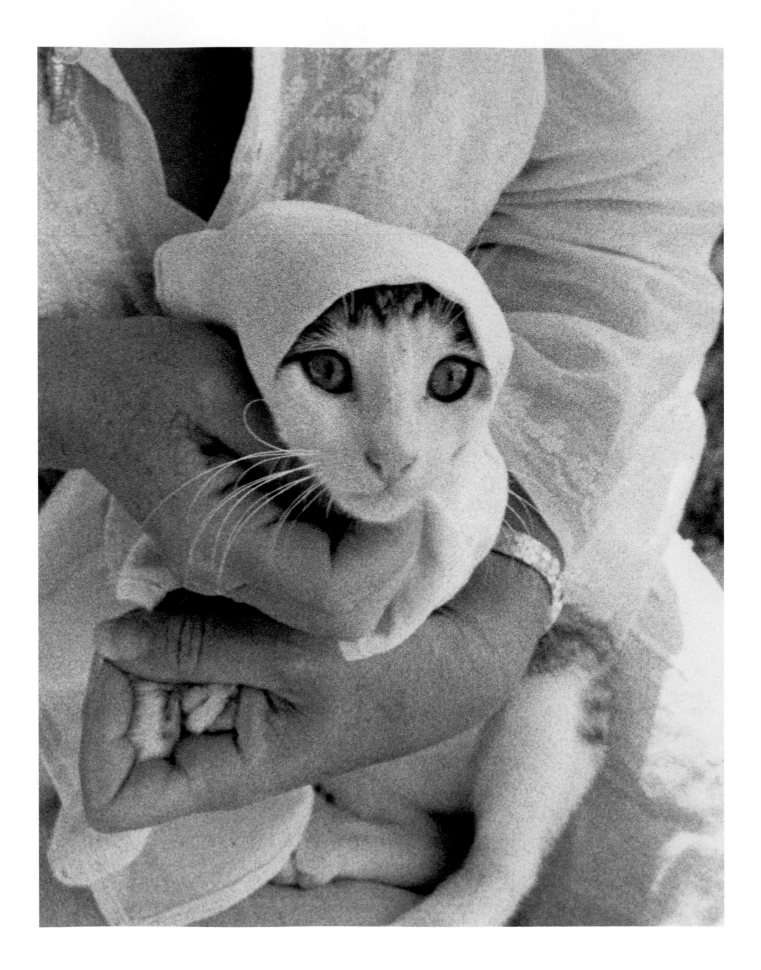

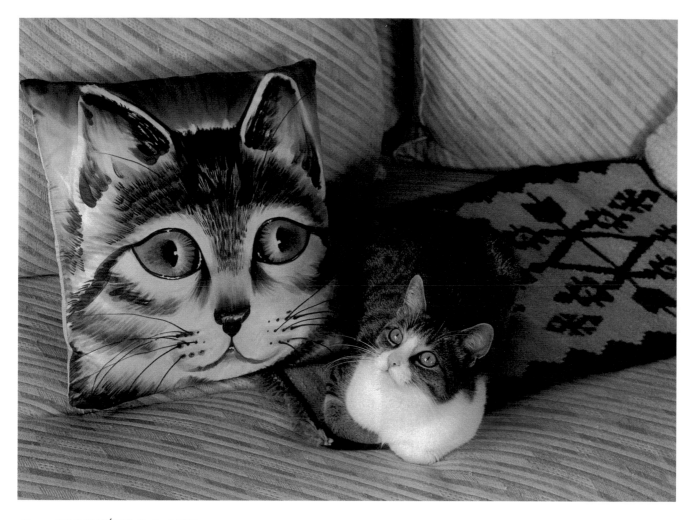

Above: JANINE NIÉPCE, Paris, 1987

Janine Niépce, a distant relative of the father of photography, Nicéphore Niépce, was one of the first French women photographer-reporters, being sent on assignments all over the globe. She covered the May '68 demonstrations in France, disguised as a foreign tourist. Her portfolio reflects her innate love for felines. "I adore animals, having grown up in the country surrounded by dogs and cats. I think my two cats, Mistigri and Meteor—who thinks he's a dog—are so gracious. The photo I shot of a cat's profile, looking at a concierge's door (see p.79) became a universal symbol of French life in the fifties."

Facing page: SIR CECIL BEATON, Mrs. John Jacob Astor's cat, Majorca, 1972

Below and facing page: YANN ARTHUS-BERTRAND, Les Mesnuls, France, 1993
Concerned with the environment from an early age, Yann Arthus-Bertrand later developed a passion for aerial
photography. Combining the two, he established the Altitude Agency, boasting a comprehensive image bank.
UNESCO's patronage enabled him to photograph the earth's most significant and remarkable landscapes—an
inventory of the ecosystems seen from the sky and reflecting the planet's actual state. The results were turned into
the impressive book, *Earth from Above*. Much earlier, he had published *Les Bestiaux*, a spectacular photographic
collection of cows, pigs, sheep, and horses. Many other books on cats and dogs followed. In his studio, he took
on the Herculean task of photographing three hundred and sixty breeds of dogs and cats with their owners.
"It is the clear relationship between the master and the animal that I want to capture. The cat is very secretive.
Its comportment is not always easily understandable to man. Dogs are different. During photo sessions,
a dog gazes dumbly at his master, but it is the master who looks dumbly at his cat."

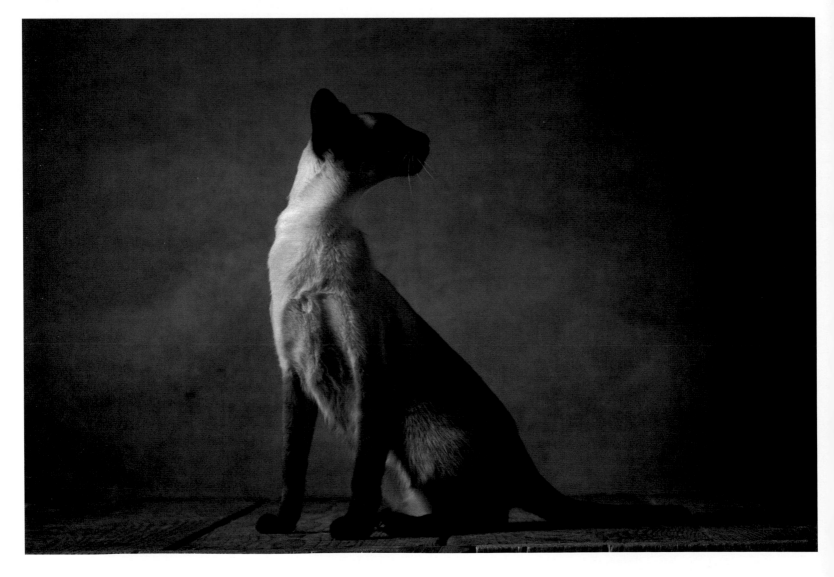

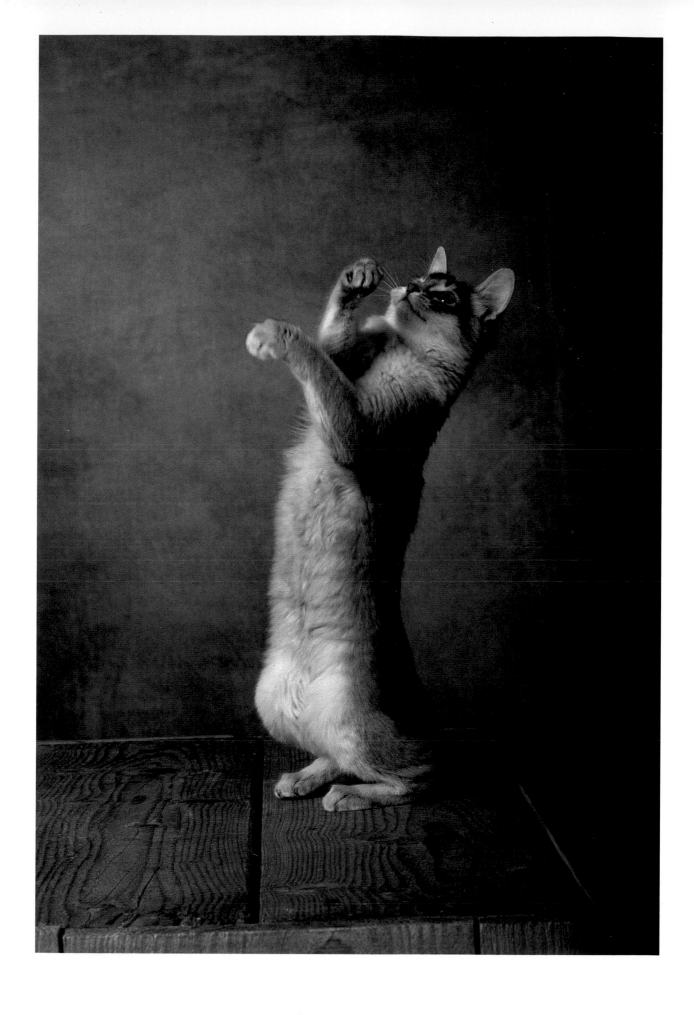

TOWN
AND COUNTRY

URBAN CATS ARE SOPHISTICATED CREATURES, WANDERING THE STREETS
AND TURNING UP EVERYWHERE—APPEARING IN WINDOW DISPLAYS,
SPRINGING IRREVERENTLY BETWEEN TOMBSTONES IN CEMETERIES,
SCAVENGING FISH AT MARKET STALLS, SEATED ON THE TABLE AT LOCAL
CAFÉS, OR LEISURELY SNOOZING IN THE SUN ON PARK BENCHES.
THEIR COUNTRY COUSINS ENJOY A BUCOLIC EXISTENCE, SHARING
THEIR LIVES WITH HORSES, ROOSTERS, AND OTHER BARNYARD ANIMALS,
OR TAKING A SIMPLE SIESTA IN A HAYSTACK.

LEONARD FREED, Naples, 1958

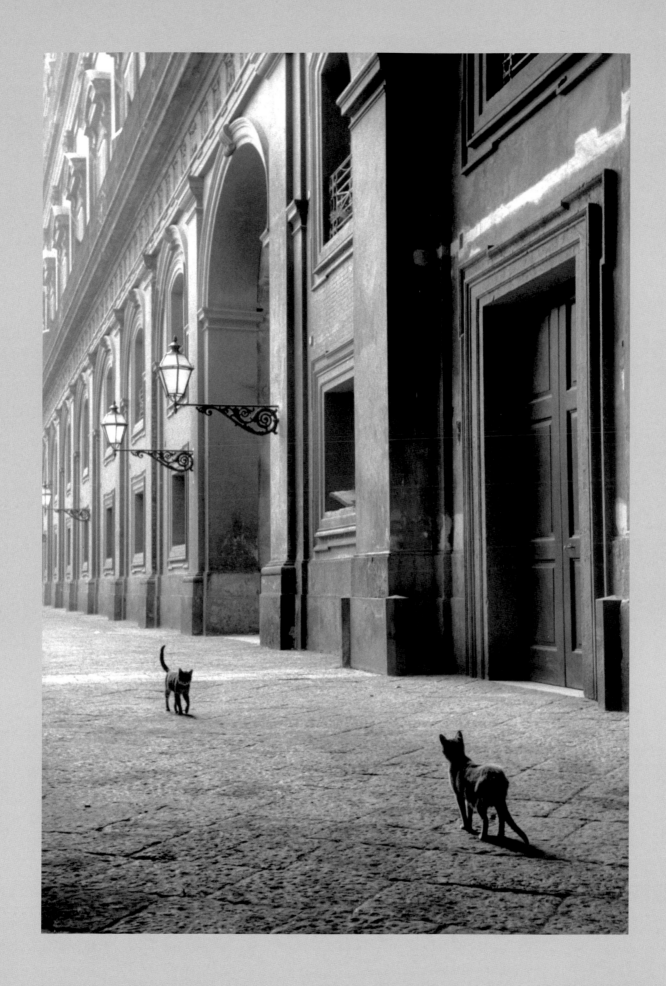

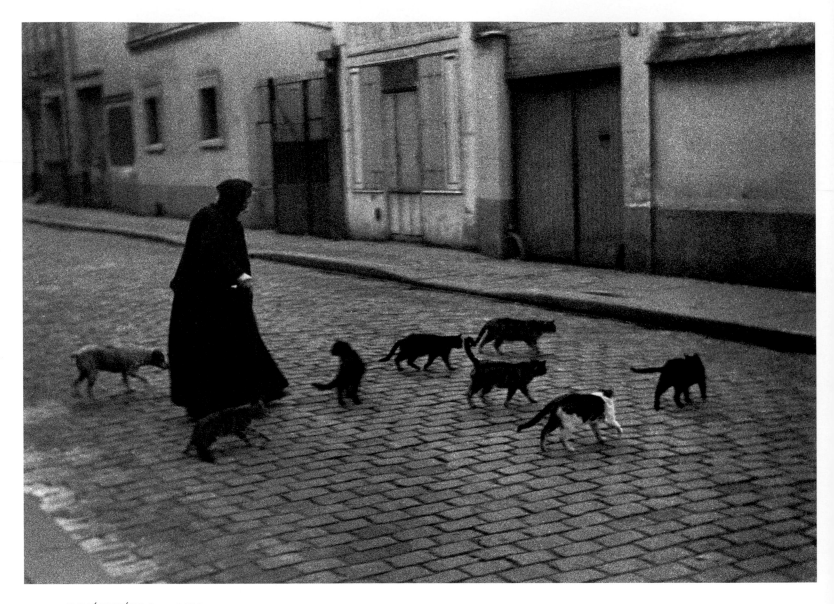

Above: ANDRÉ KERTÉSZ, Paris, 1931

Preceding page: LEONARD FREED

Leonard Freed achieved international acclaim with his photos on the American civil rights movement, police brutality, racial discrimination, and the Ku Klux Klan, as well as on subjects reflecting his own Jewish roots. A feline fanatic, he had eight at one time but is now down to three. He does, however, have a cat cemetery, embellished with a donated cat sculpture, for those who want a proper burial for their treasured pets. "Professionally," he pointed out, "I am only interested in photographing animals as I do humans—in their environment. I look for opportunities to photograph buildings in relation to the people who use them. In the Naples shot with two cats staring each other down, I tiptoed as close as possible to get those cats on the palace grounds, since they have the same right to be there as the locals. In general, when photographing cats, you must establish a relationship and show respect; don't dictate the pose or call them back."

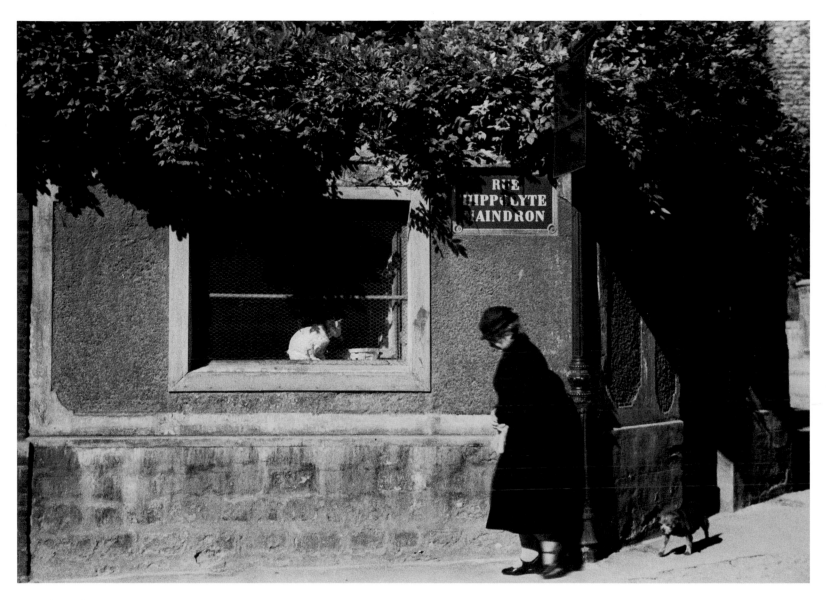

ANDRÉ KERTÉSZ, rue Hippolyte Maindron, Paris, 1928

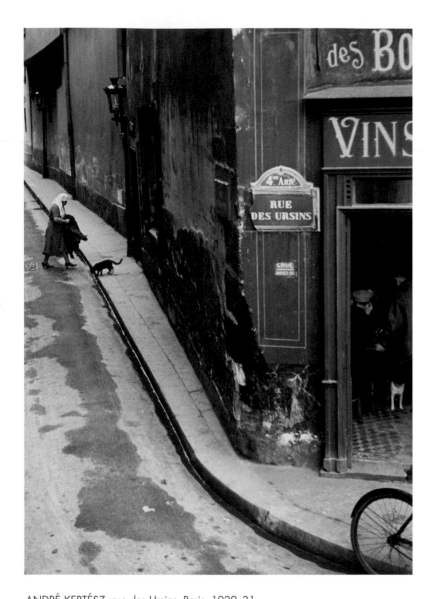

ANDRÉ KERTÉSZ, rue des Ursins, Paris, 1929–31
During the seventy years of his career, André Kertész, using mostly a small-format camera, photographed the images of ordinary life without any pretensions. From portraits to still lifes, nude distortions to photojournalism, he always managed to capture the telling moment. The first to master the newly invented Leica in the twenties, he could move easily on the streets of Paris, snapping spontaneously. After settling in New York in the late 1930s, he worked as a freelance photojournalist for *Vogue*, *House and Garden*, and *Harper's Bazaar*. His influence on world photography was enormous. "Whatever we have done, Kertész did first," acknowledged Henri Cartier-Bresson.

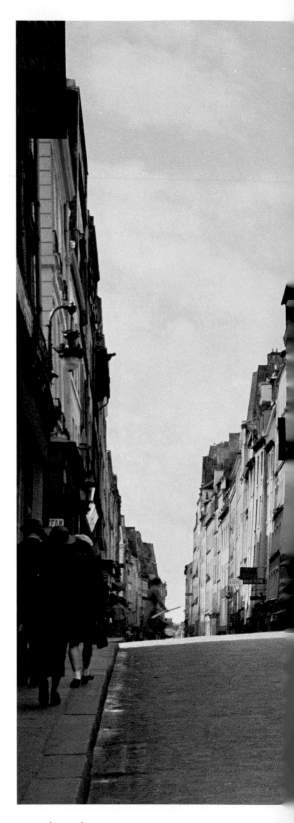

ANDRÉ KERTÉSZ, porte Saint-Denis, Paris, 1928

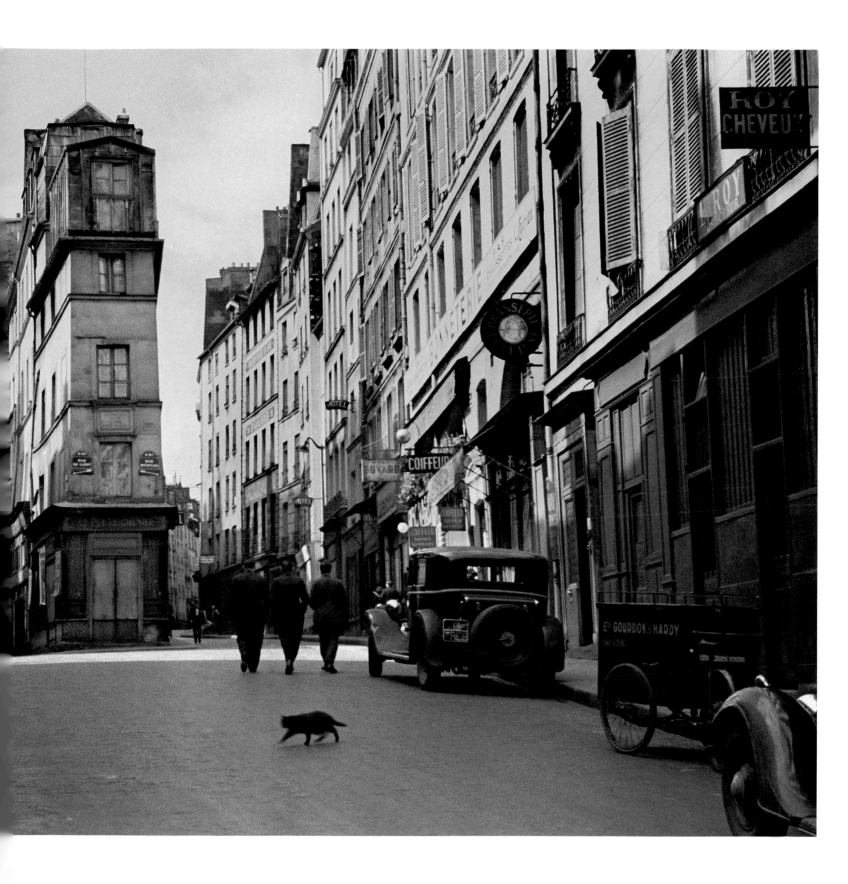

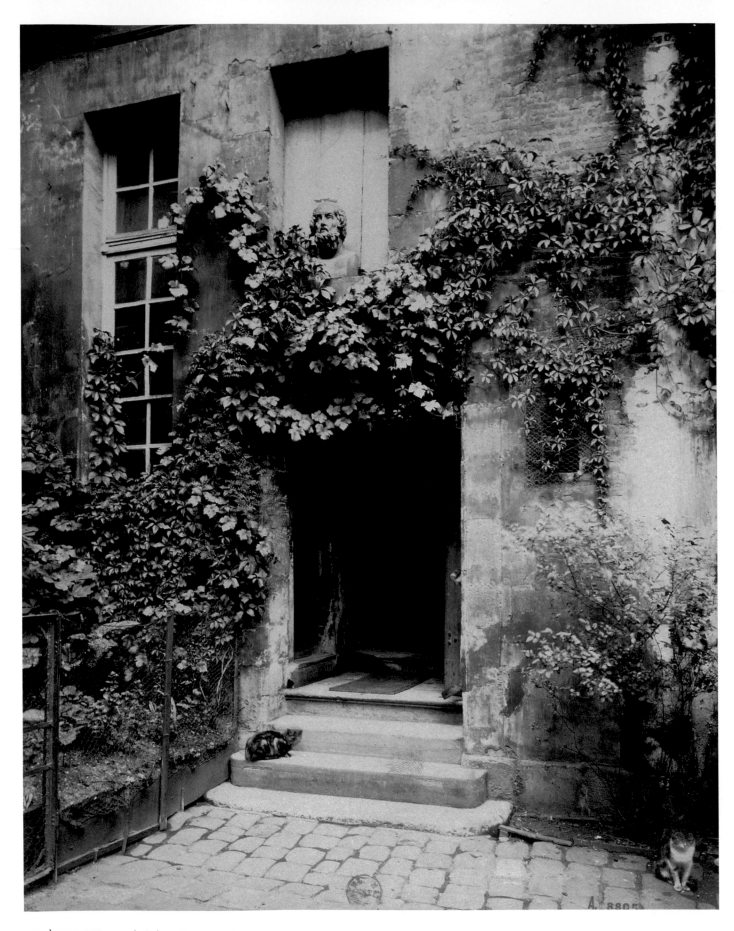

EUGÈNE ATGET, cour de Rohan, Paris, 1922

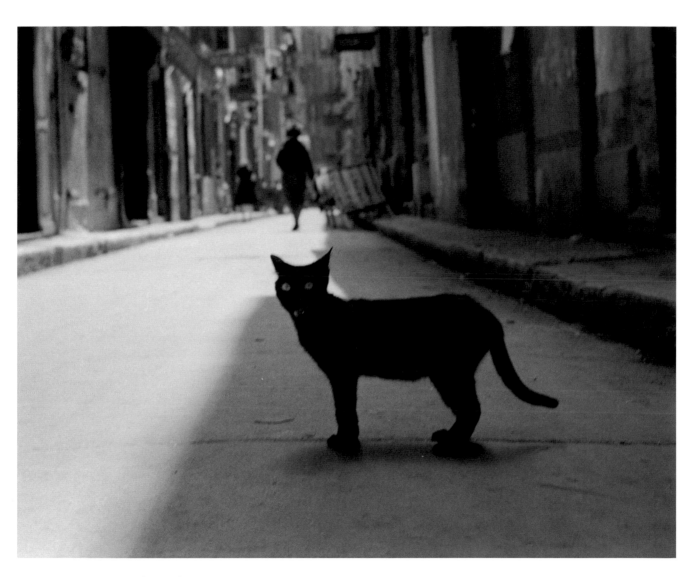

RAYMOND VOINQUEL, *The Black Cat*, 1938

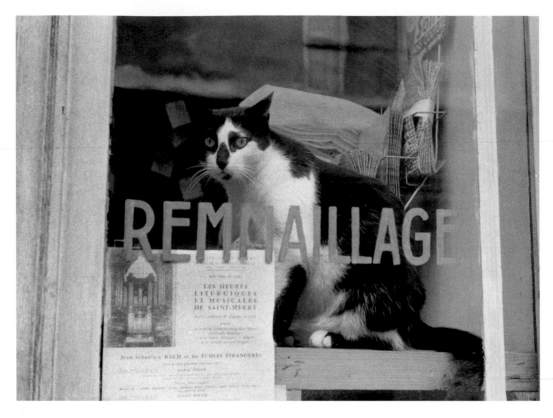

MARCEL BOVIS, Cat in a seamstress's shop window

Marcel Bovis, a self-taught photographer, began in 1927 with a series on Paris at night, and over
the following six decades he documented a myriad of subjects, ranging from holiday celebrations, country fairs,
and the French provinces, to architecture and nude studies. He experimented with collages and photomontages
and was prominent in the influential Groupe des XV, an exclusive association of the most important
photographers in France, including Ronis and Doisneau. His books, *150 Years of French Photography*
and *French Cameras*, mark him as a historian and author as well. Bovis was also an active defender of
photographers' copyrights.

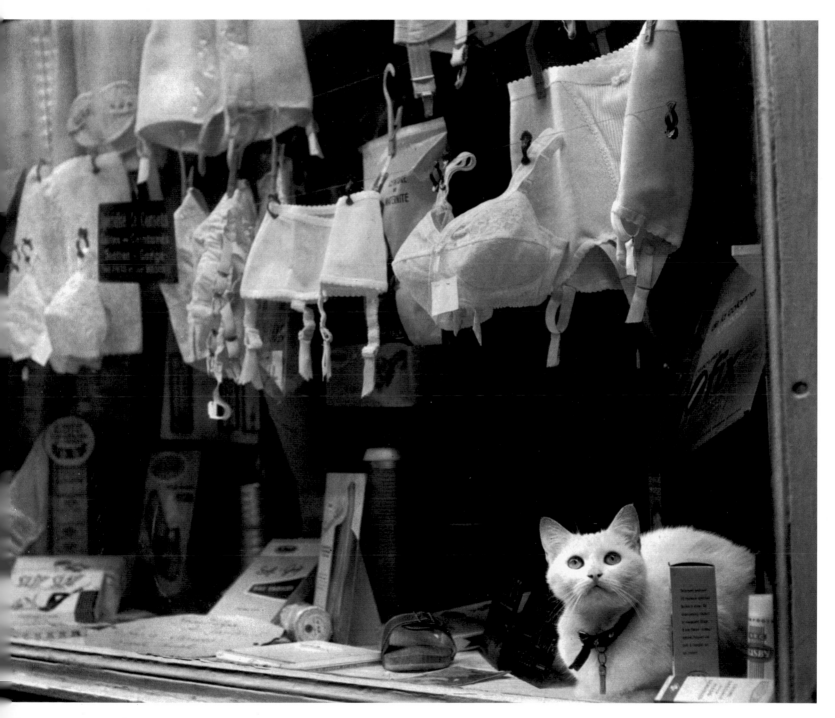

HENRI CARTIER-BRESSON, Lille, France, 1968

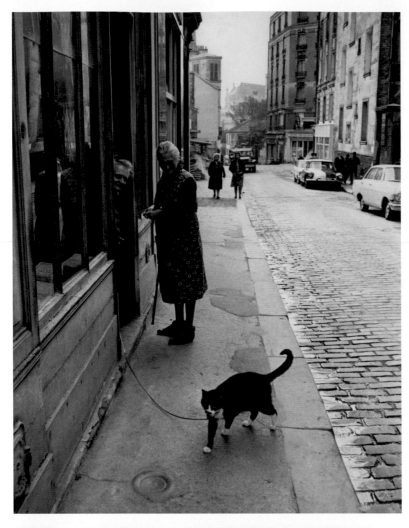

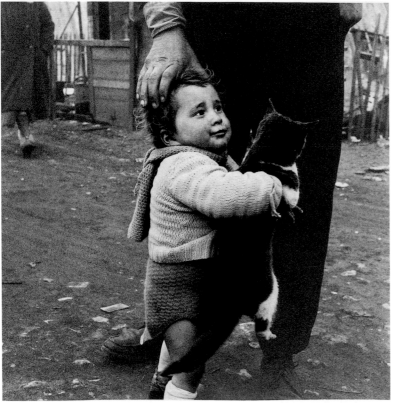

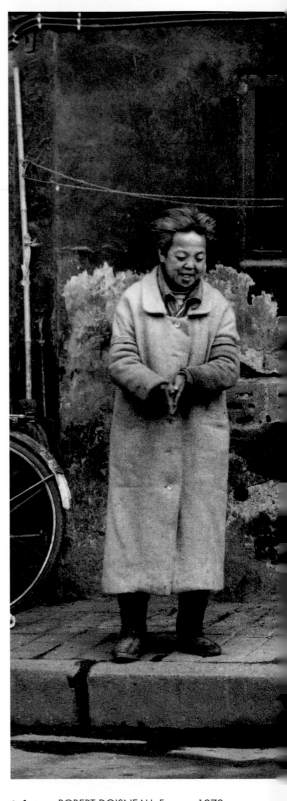

Left, top: ROBERT DOISNEAU, France, 1972

Left, bottom: JACQUES-HENRI LARTIGUE, *Bidonville [Shanty Town] in Noisy-le-Grand*, 1963

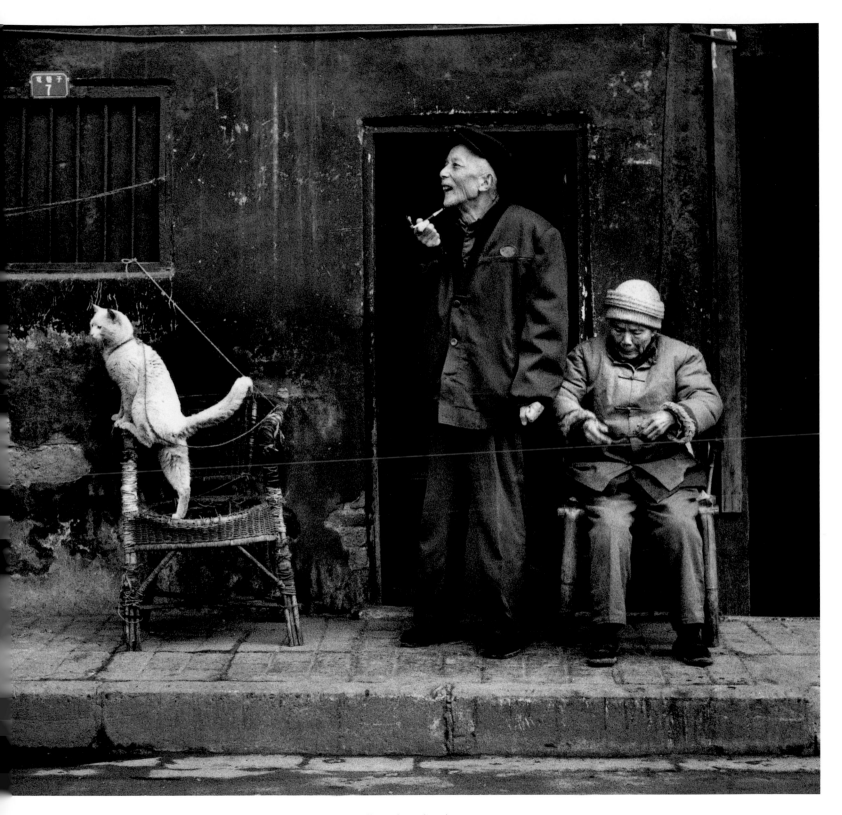

Above: WU JIALIN, *Kuan Xiang Zi* (Large Alley) Chengdu, China, 1999
Wu Jialin, a prominent Chinese photographer, directed the House of Pictures
in the province of Yunnan. His photos were chosen by Cartier-Bresson
for his foundation collection

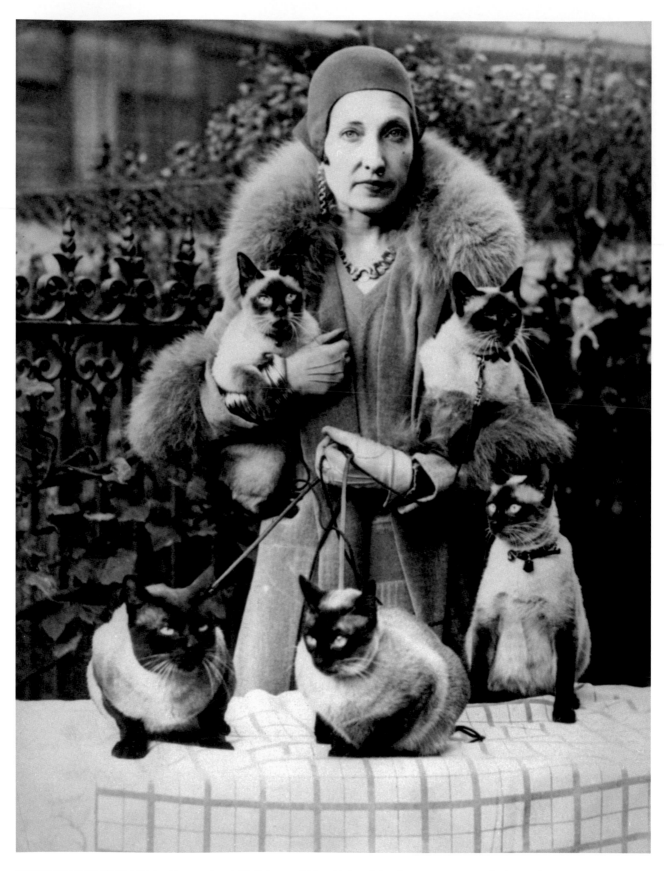

PHOTOGRAPHER UNKNOWN, Mrs. Frederich H. Fleitman of New York with her five Siamese cats, which won first prize at the International Show of the Cat Club, Paris, 1930

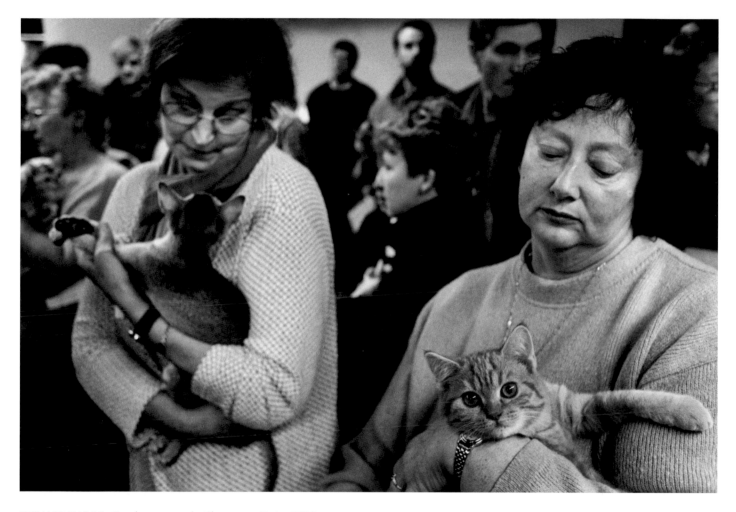

RICHARD KALVAR, Cat show, porte de Champeret, Paris, 1998
Not all photographers reflect total reality in their images. Richard Kalvar begins with reality, but his photos
reflect a parallel vision—darker, yet more humorous. Regarding cats in his work (aside from the fact that
his wife is allergic), he said, "I'm not a cat or cat show specialist. I'm interested in the life that surrounds me,
generally human, sometimes canine, and occasionally feline. I also do bovine and ovine, now and then.
And ursine. And asinine—I have a very nice picture of a donkey!"

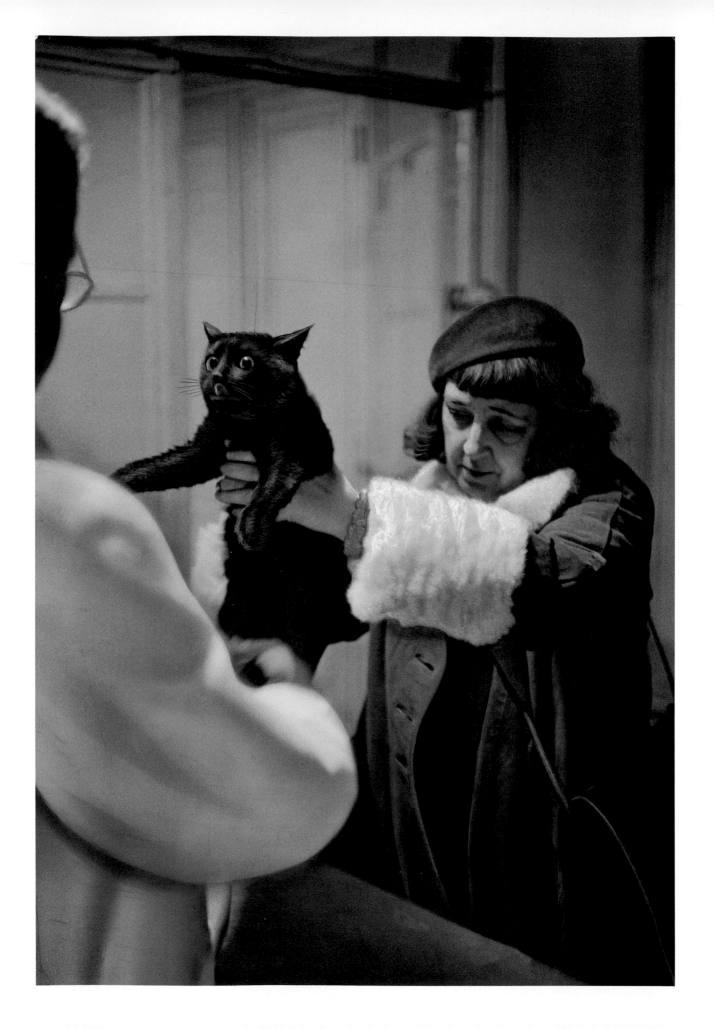

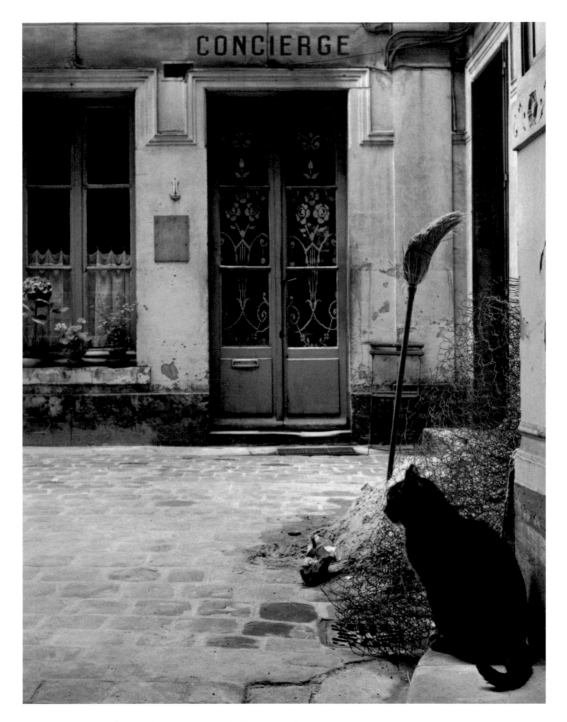

Above: JANINE NIÉPCE, *The Concierge's Black Cat*, rue de Tournon, Paris, 1957

Facing page: MARC RIBOUD, Pet clinic for free animal treatment, Paris, 1953
Marc Riboud, who has been circling the globe for over fifty years, has focused his work on the human element.
Recognized for his sympathetic photos of the poor and homeless, those who are overlooked and unwanted,
he does not pass judgement but depicts what he sees, the essence of those before him. He said: "Photography must
not try to be persuasive. It cannot change the world, but it can show the world, especially when it is changing."

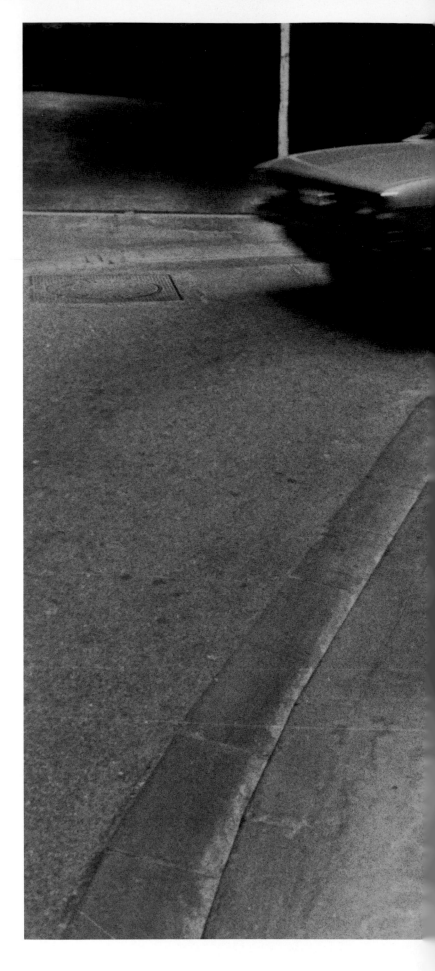

JEAN DIEUZAIDE (YAN), *An Arles Cat*, France
Jean Dieuzaide's decision to pursue a photographic career was made for
him during the liberation of Toulouse. He was the only person to have
photographed the historic event, which led to a request by the Prime Minister
for these photographic documents. Dieuzaide subsequently took the first official
portrait of Charles de Gaulle. His family insisted that he use a pseudonym.
He was "Yan" until 1971 when, after being immobilized for more than six months
following an automobile accident, he resumed photography under his real name,
Dieuzaide. He became famous after *Life* magazine published his photos of
a marriage between two tightrope walkers, which he shot astride the shoulders
of an acrobat.

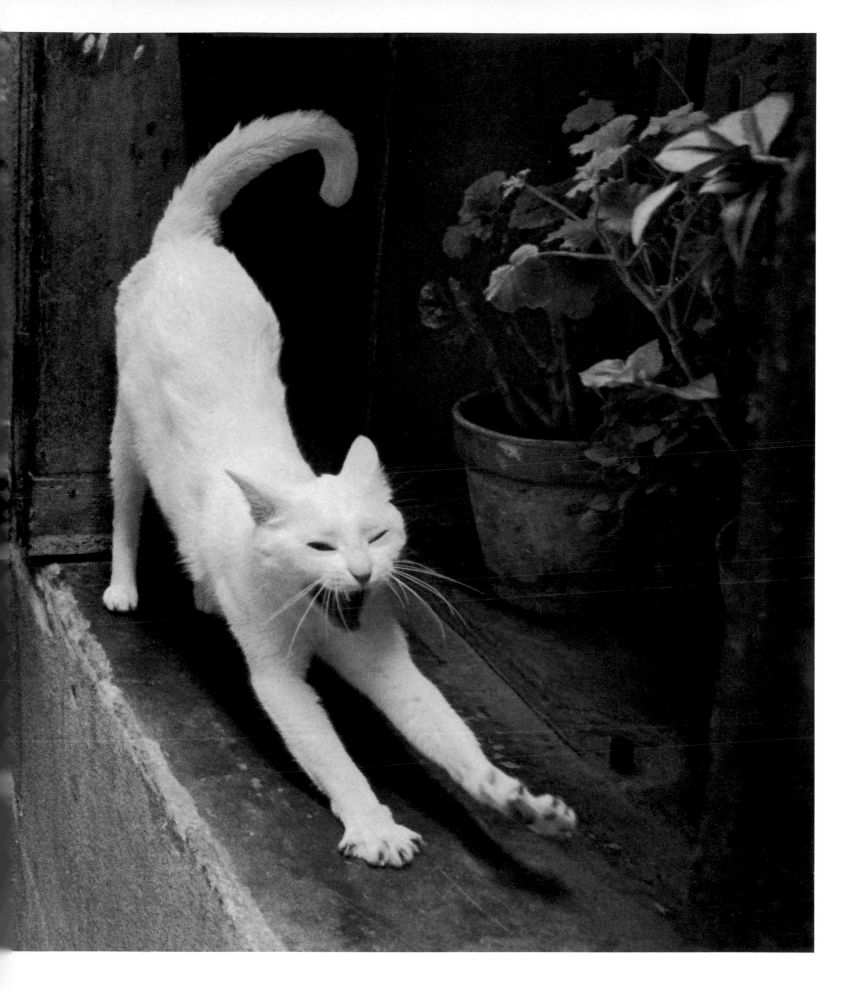

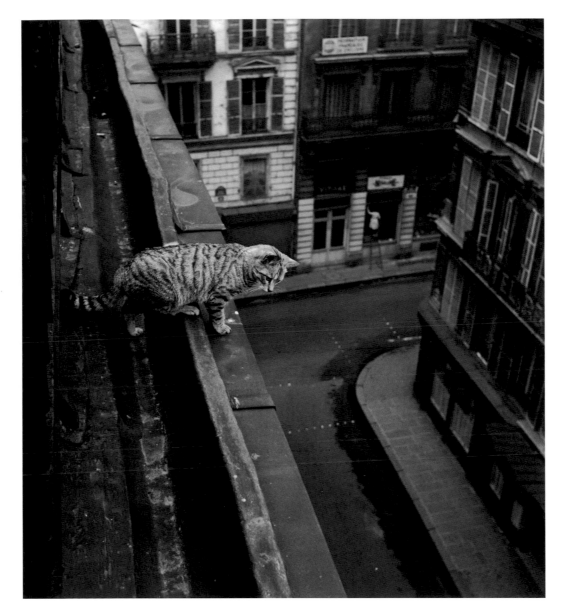

Above: MAURICE ZALEWSKI

Facing page: MARIE BABEY, canal Saint-Martin, Paris, 1989
Marie Babey's documentary photojournalism has extended from daily life in her Parisian neighborhood, canal Saint-Martin, to firemen, marine commandos, aviators and—very close to her heart—cats. "When my cat, Virgile, died, I lost my most loyal companion. More loyal than a dog, he followed me everywhere. The only place he wouldn't come was my photo lab, since he objected to the brusque changes in light. Virgile absolutely would not pose, so I was really lucky one Sunday to catch him walking back in the roof gutter, while the cyclists in the "Tour du canal" passed under my window. Virgile became world famous thanks to that photo."

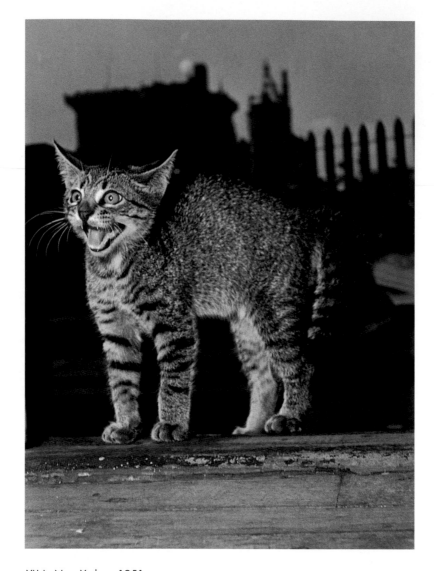

YLLA, New York, c. 1951
Camilla Koffler, better known as Ylla, grew up during the difficult years of World War I,
and had hoped to become a sculptor. After an apprenticeship with the Hungarian
photographer Ergy Landau, she decided to become a photographer. Fascinated by
animal photography, she became famous for her portraits of animals in zoos and later of
wild animals in their natural habitat. She died tragically in India while photographing a
bullock cart race, when she fell from the hood of a jeep.

Facing page: HENRI CARTIER-BRESSON, *Europe*, 1987

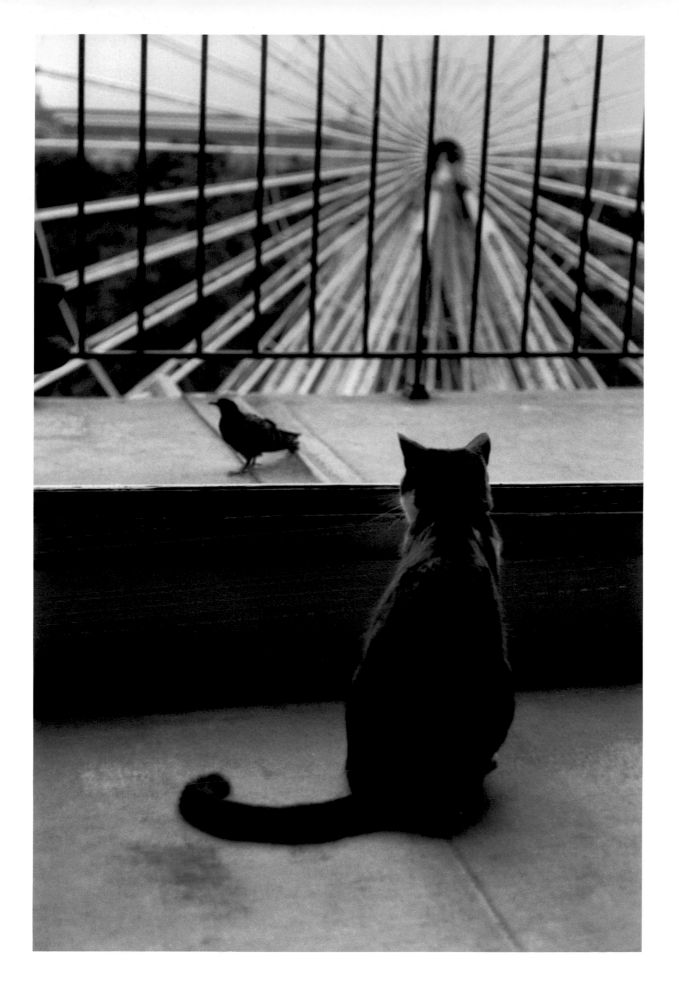

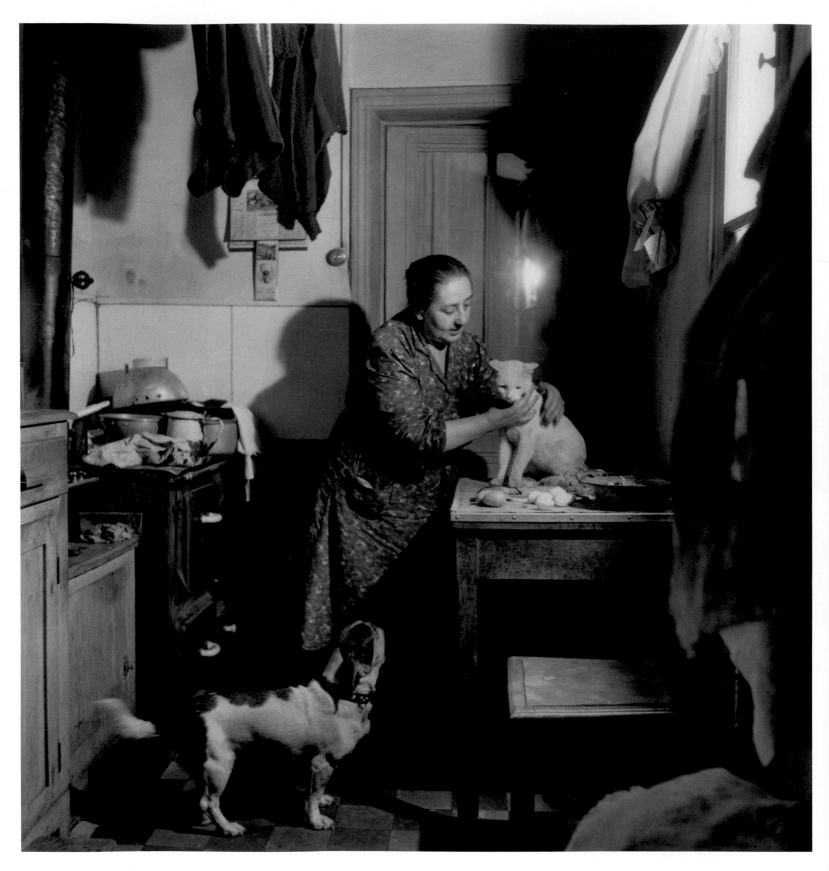

ROBERT DOISNEAU, *The Concierges*, France, 1963

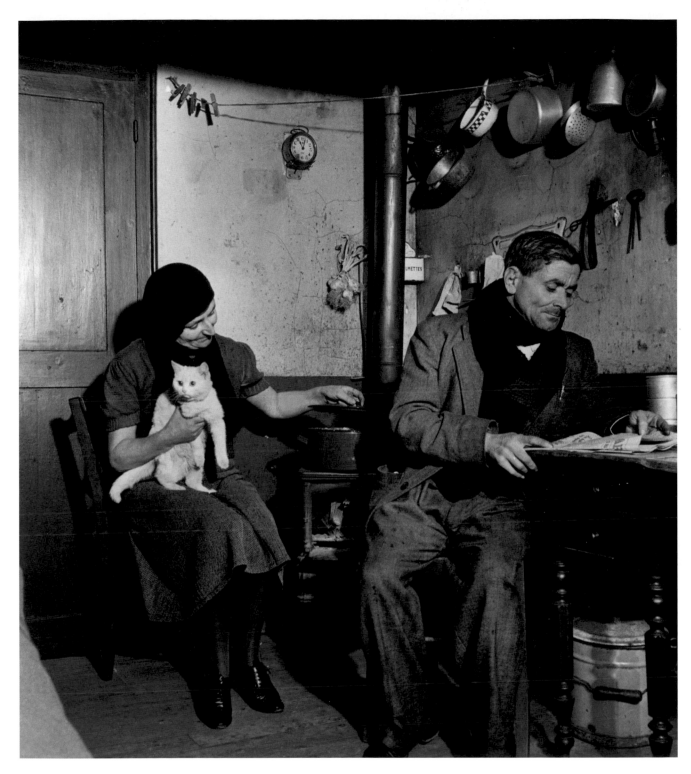

WILLY RONIS, Destitute family surviving on CARE aid
packages from the U.S., following World War II, Paris, 1949

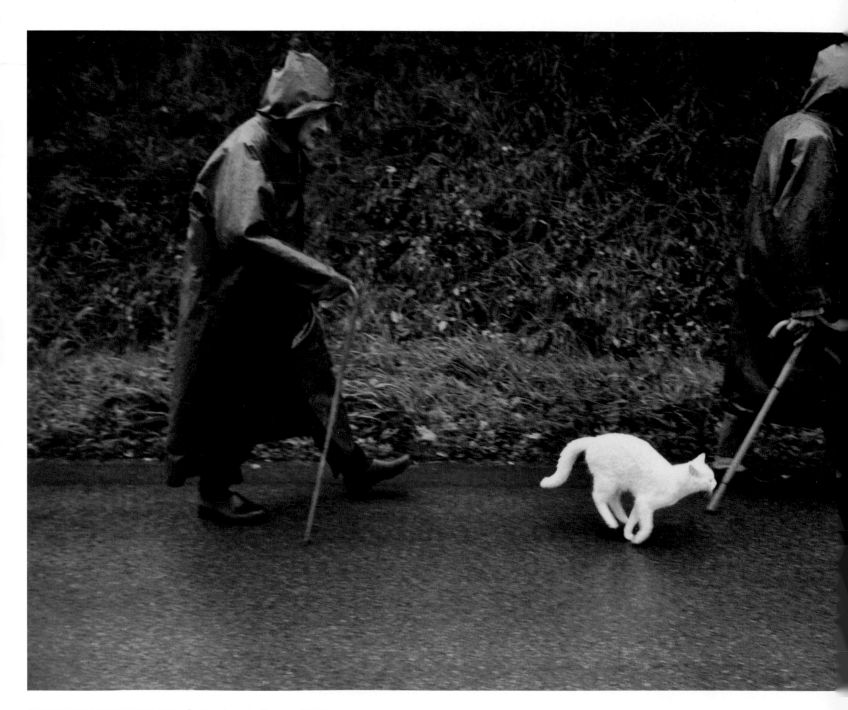

FRANÇOIS LE DIASCORN, Twins fleeing the rain, France, 1982

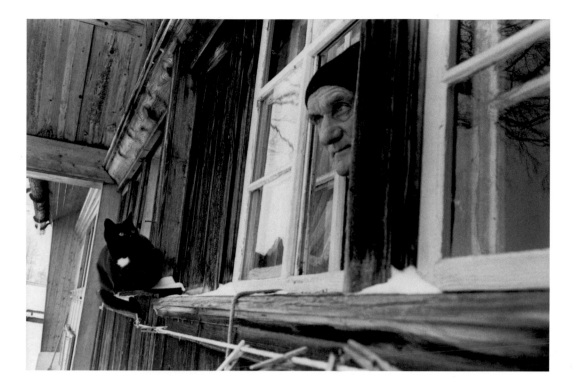

FRANÇOIS LE DIASCORN, Urnäsch, Appenzel, Switzerland, 1977
After studying political science and law in Paris, François Le Diascorn took a trip to India in 1971 that changed the path of his life. He decided to become a photographer. From the very beginning, he was especially attracted by the unusual, the strange, and the mystical, and he has traveled all over the world, shooting the most eclectic of subjects. "I am drawn to that which is a little disturbing in daily reality, the mystery that lurks behind the common occurrences," explains Le Diascorn. "My own cat, Kali—black with phosphorescent yellow eyes, named after the Indian goddess of darkness and death—is beautiful, disdainful, appearing and disappearing like shades of the night. I have spent a lot of time trying to capture her elusiveness which, in a way, I do all the time as a photographer—going after that which is fleeting, which appears and disappears, like the black cat Kali."

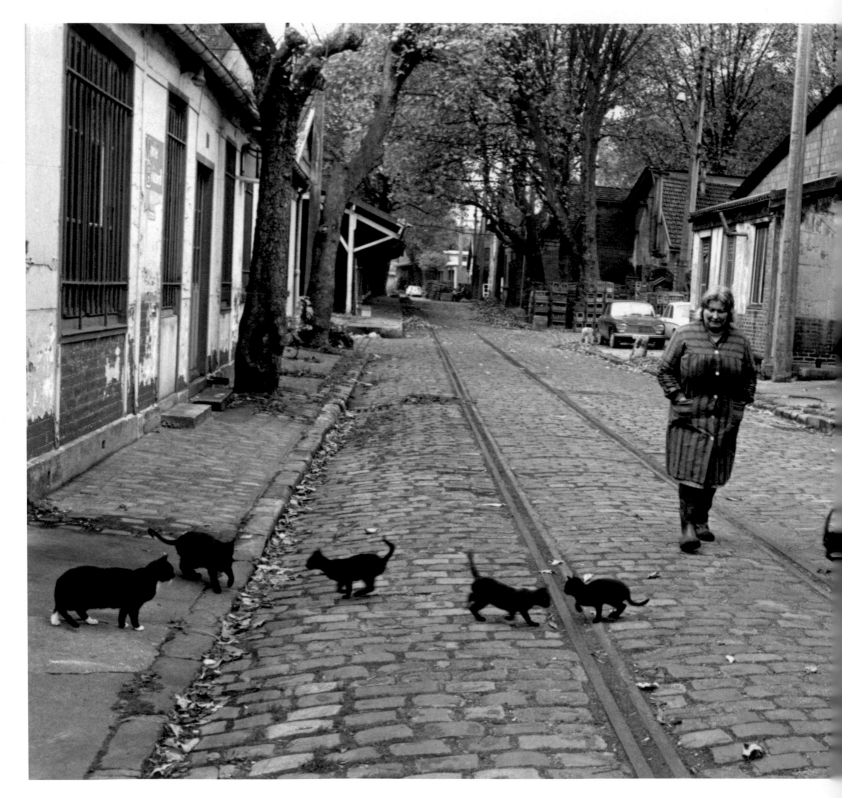

ROBERT DOISNEAU, *The Cats of Bercy*, Paris, 1974

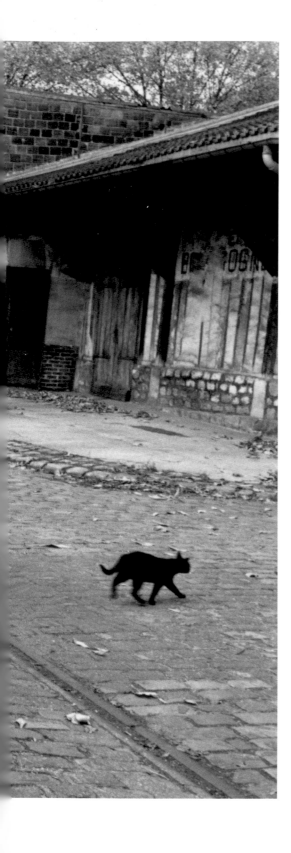

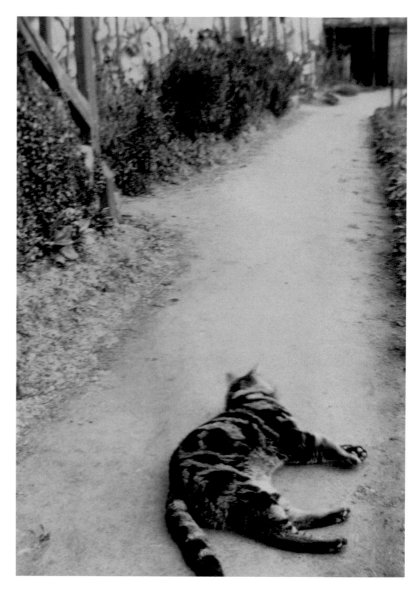

RENÉ LALIQUE, Page from a photo album, La Benneterie, Yvelines, France, 1905
Internationally celebrated for his glass and jewelry design, Lalique was also
an accomplished photographer whose extensive photographic work is displayed in
the Musée d'Orsay, Paris.

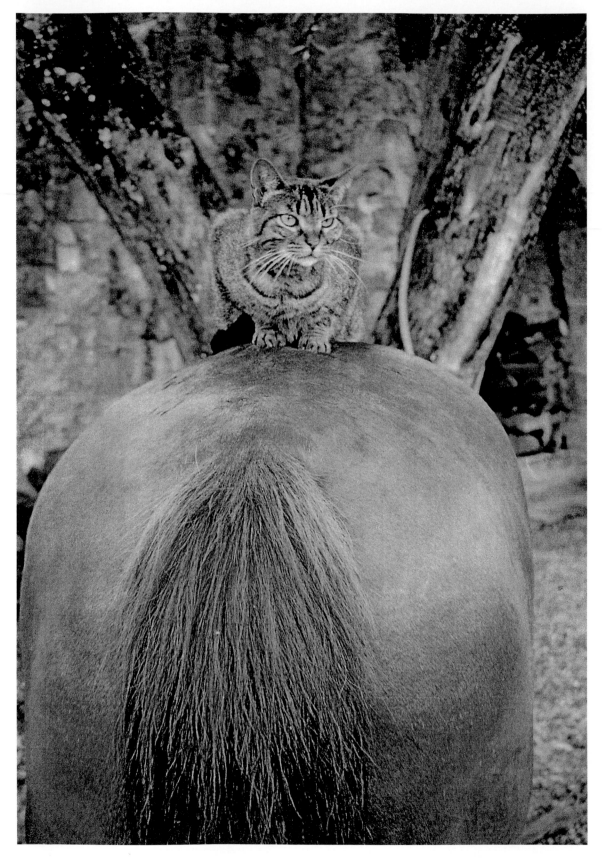

ARIANE, Provence, France, 2000

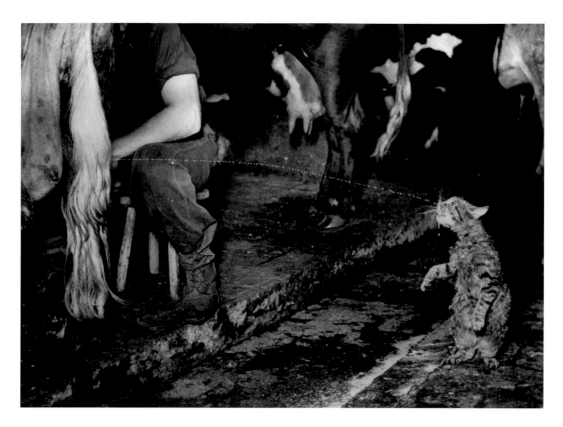

FRANK LANE, London

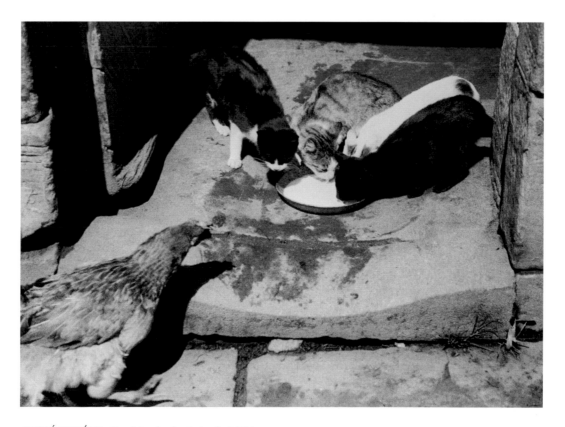

ANDRÉ KERTÉSZ, *Our Friends, the Animals*, 1934

CATS ON THE MOVE

WHEN THEY ARE NOT SOUND ASLEEP, CATS ARE THE MOST PLAYFUL
OF CREATURES—TO THE JOY OF PHOTOGRAPHERS. CATCHING A CAT
FLYING THROUGH THE AIR OR LEAPING ACROSS A VOID MAKES FOR
A SPECTACULAR PICTURE. IN THEIR MOVEMENTS, THEY ARE AS AGILE
AS ACROBATS, AS GRACEFUL AS DANCERS, YET MENACING IN FRONT
OF PREY OR WHEN FACING DOWN THE NEIGHBORHOOD DOG.
SINCE THE EARLIEST DAYS OF PHOTOGRAPHY, MASTERS OF THE CAMERA
LENS HAVE EXPERIMENTED WITH CAPTURING CATS IN MOTION.

YLLA, New York, c. 1951

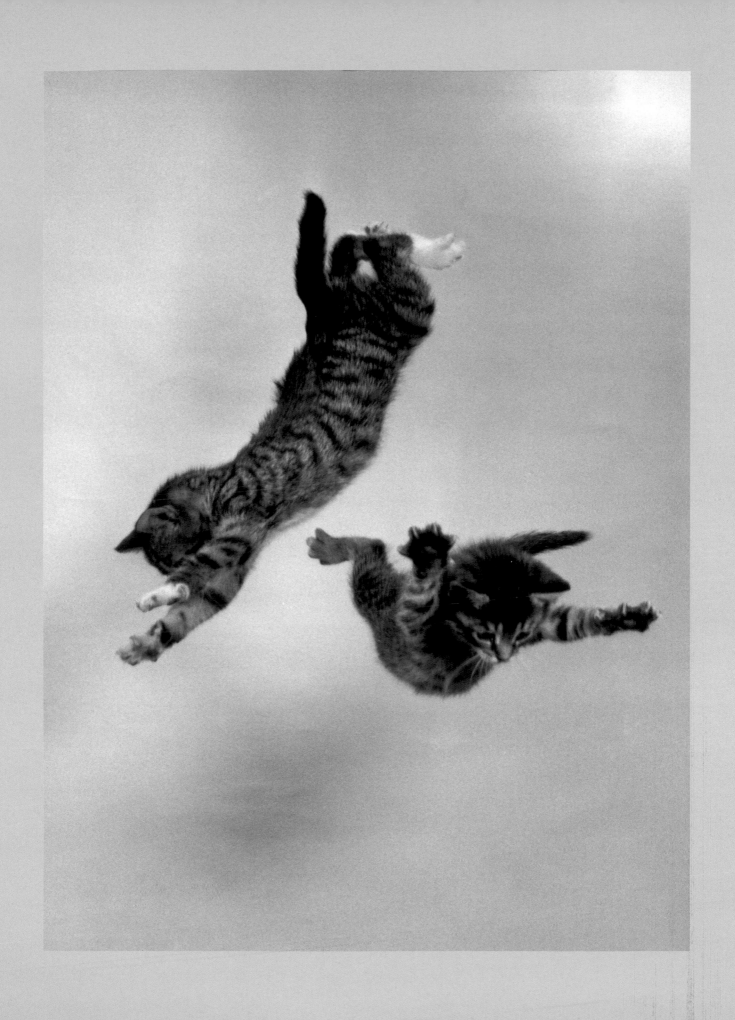

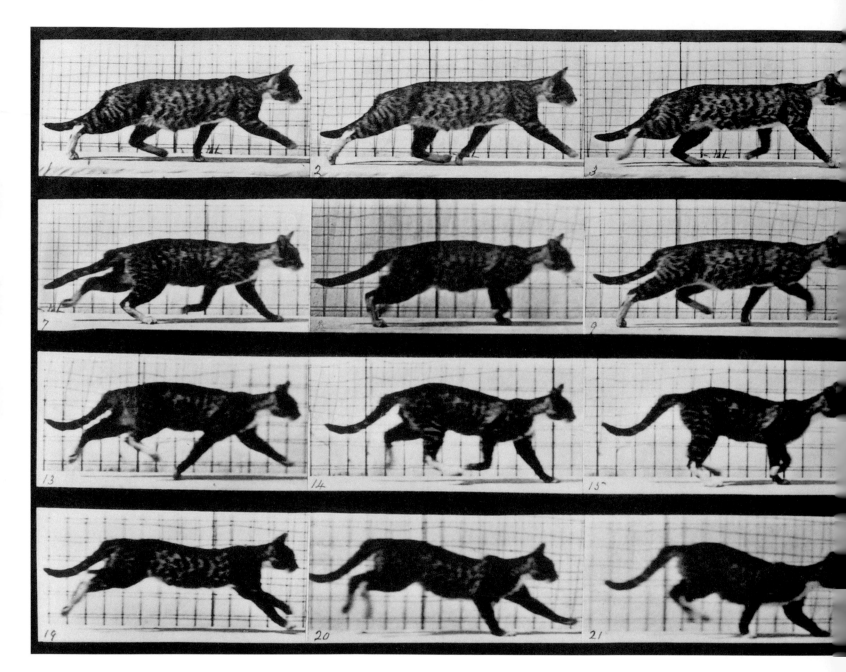

EADWEARD MUYBRIDGE, Cat in motion, 1887
In 1884, Eadweard Muybridge experimented with photographing animals in
motion, from horses and pigs, to lions and tigers in captivity, and finally he focused
on cats. He succeeded not only in photographing a feline in its three forms
of momentum—sauntering, trotting, and galloping—but froze on film the phases
of passing from one pace to another.

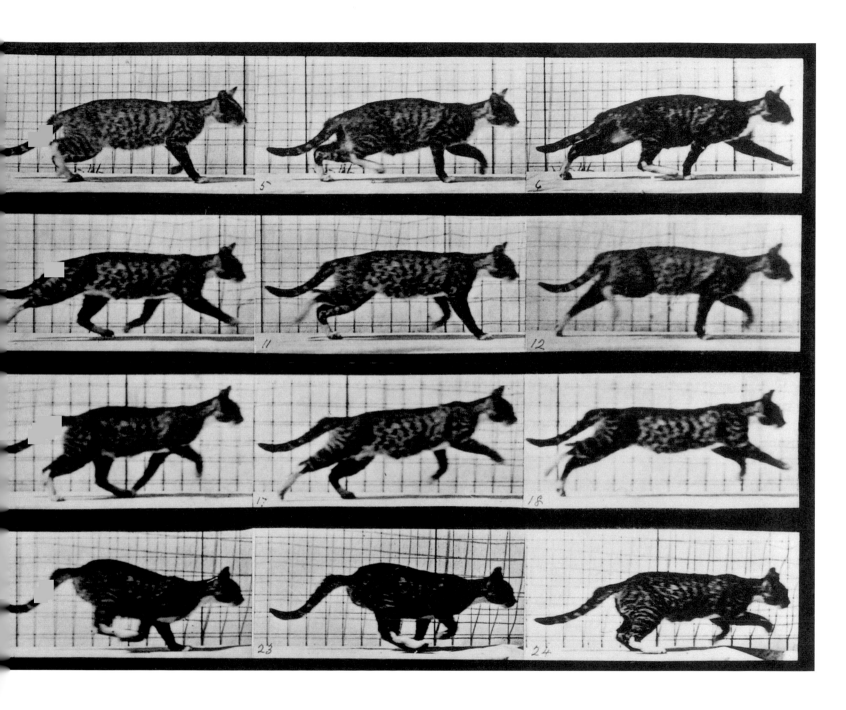

PIERRE BONNARD, His sister and her children at the family home, Noisy-le-Grand, France, 1898–99
As a young man in the late nineteenth century, Pierre Bonnard—who would later achieve world fame for
his colorful paintings of everyday life—was photographing domestic scenes in black-and-white with a primitive
camera. Although known today for his Impressionist paintings, he never put his camera away and took
many snapshots of his family, as well as voluptuous nude portraits of his shy model and mistress, Martha,
who later became his wife.

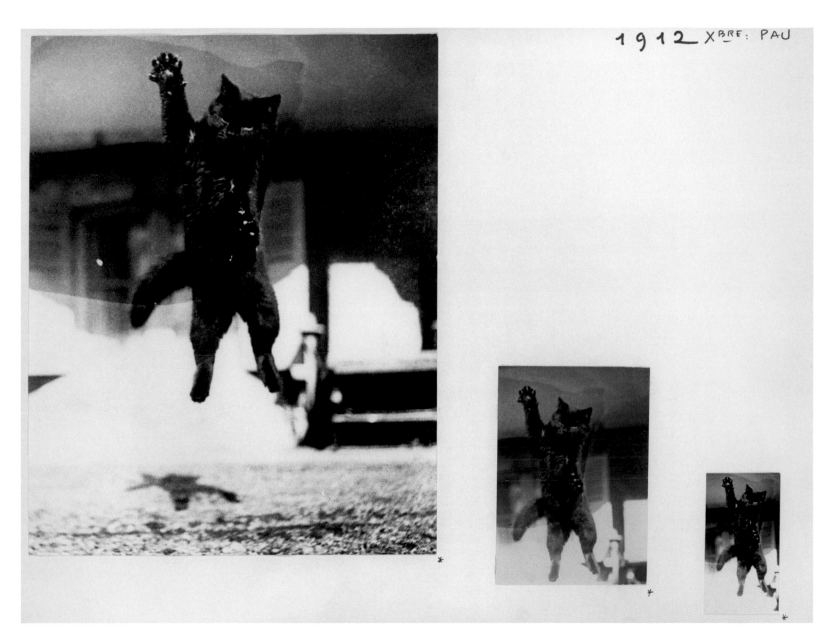

JACQUES-HENRI LARTIGUE, Page from a photo album, Pau, France, 1912

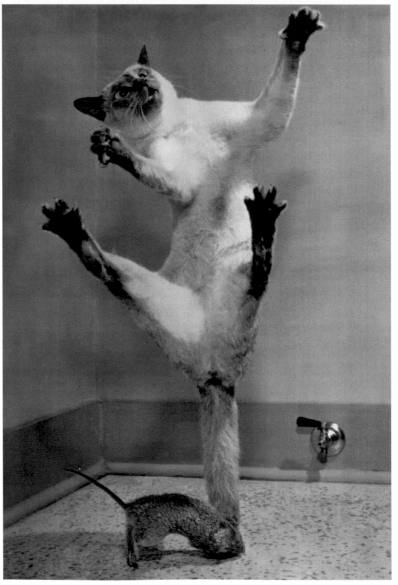

Left, top: KEYSTONE, French country fair, 1933

Left, bottom: GILBERT BARRERA

Facing page: K.J. GERMESHAUSEN, U.S., 1948

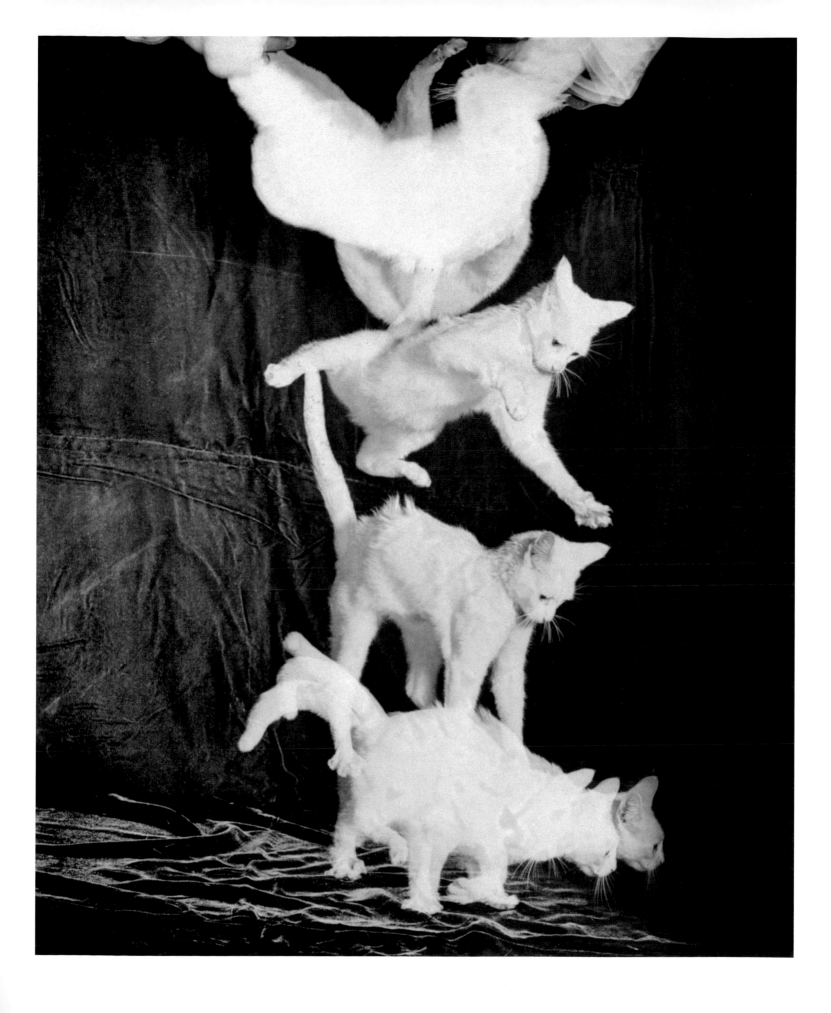

PHILIPPE HALSMAN, *Dalí Atomicus*, Halsman Studio, New York, 1948
A far cry from the realistic approach and on a completely different note
is Philippe Halsman's intriguing "Jumpology" series, beginning with *Dalí Atomicus*.
How did he achieve this phenomenal photograph, with the Spanish surrealist
in mid-air along with furniture, water, and three cats? It turned out to be a studio
set-up, with a suspended easel, a stepping stool, and two of Dalí's paintings (one
was *Leda Atomica*), while Yvonne, his wife, held up a chair. On the count of three,
Halsman's assistants threw three cats and a bucket of water into the air. At the
count of four, Dalí leaped and Halsman clicked away, using the 4 × 5" format,
twin-lens reflex camera that he had designed a year earlier. While the assistants
consoled the cats and mopped the floor, Halsman developed the film in the
darkroom before starting all over again. In his book, *Halsman on the Creation
of Photographic Ideas*, the photographer wrote: "Six hours and twenty-eight takes
later, the results satisfied my desire for perfection. My assistants and I were wet,
dirty, and near complete exhaustion—only the cats still looked as good as new."
According to Halsman, the cats actually enjoyed the exercise and were quite
willing to continue!

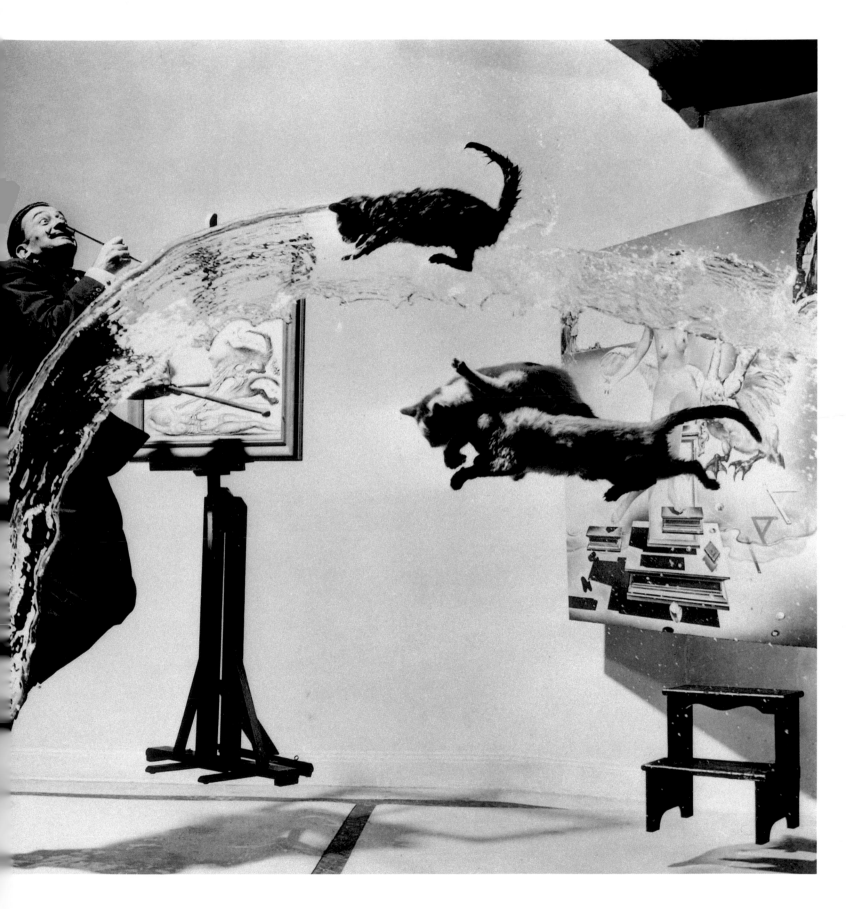

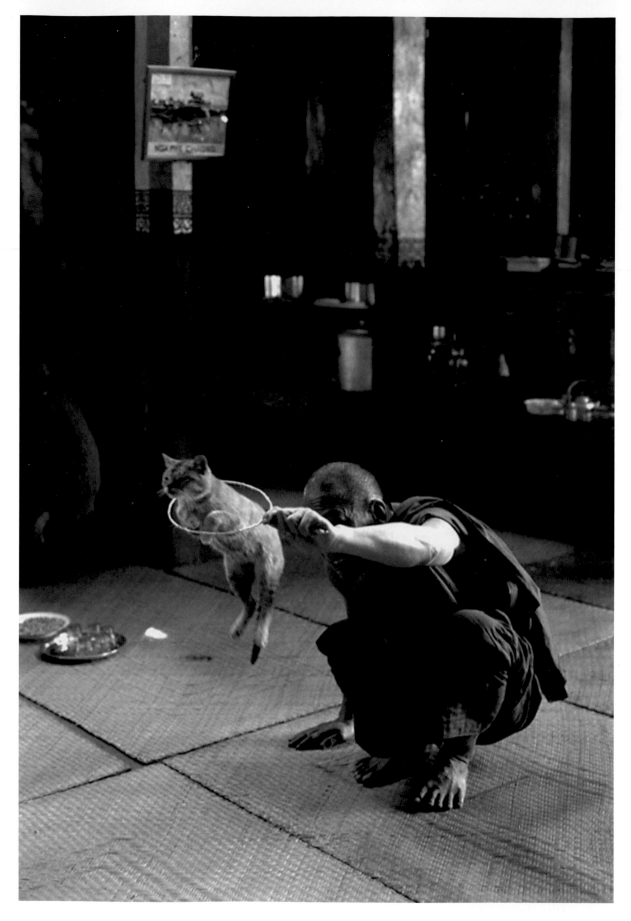

SABINE WEISS, Monk in a temple near the Lake of Inle, Burma, 1996

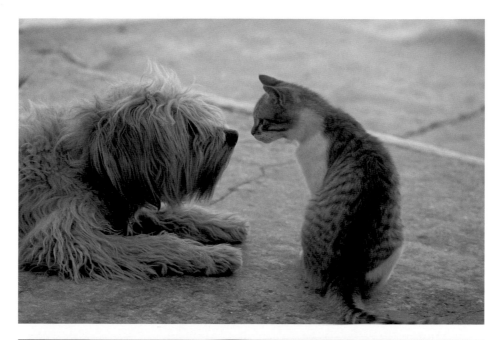

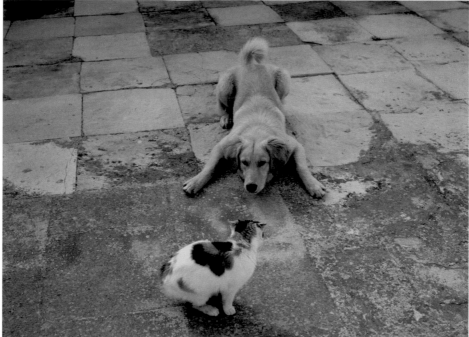

Top: PIERRE PUTELAT, Syros, Greece, early 1990s
For the past three decades, Pierre Putelat has been photographing the stark wilderness of
the Queyras, in the French Alps, where he lives, as well as the idyllic serenity of Greek island life,
focusing on the myriads of cats which populate the villages and ports. His strong attraction to felines
has been inherited by his four children, who love both cats and Native American legends. "They've
given their furry friends Indian names: Cheyenne, Tepee, Apache, Chinook, Tanka, and Coyote."

Bottom: HANS SILVESTER, Mykonos, Greece, 1993

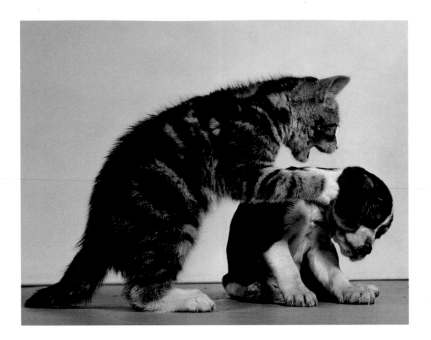

Above: YLLA, New York, c. 1951

Facing page: ELLIOT ERWITT, France, 1995
World recognition came to Elliot Erwitt with his photos of the Nixon-Khruschev "kitchen debate" in 1959. Erwitt is no cat-lover. When asked about his attitude toward cats, he replied, "I'm not sure that this is what you would like to hear from me, but then again, why not. It may be a bit different from the usual fawning over our feline friends. As a confirmed dog person, I feel that cats are definitely an acquired taste. Sure, they are good-looking and graceful and move well, but they are also brutally cruel to their prey, self-centered in their habits, often too finicky for their masters—that is, if you can actually be the master of a cat. But most disconcerting for me is that no cat would bark when my doorbell rings, or would be there to support me when I might need total, unqualified love. Perhaps those are the very qualities that are most attractive to cat fanciers. Still, in all my dog books, I include at least one cat photograph, as a gesture in their honor."

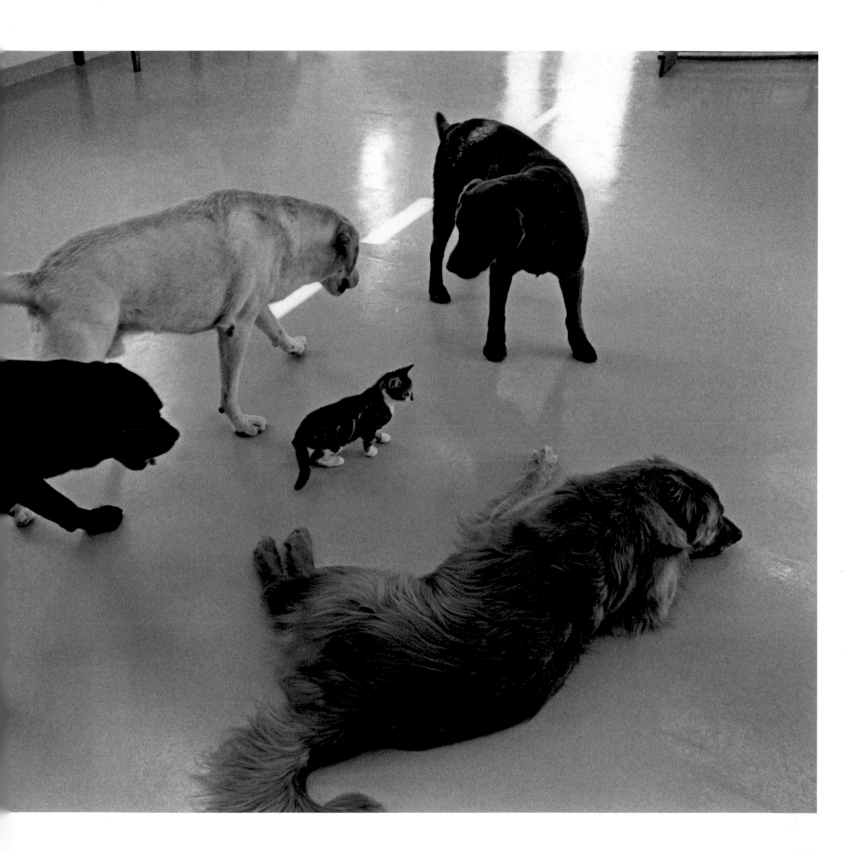

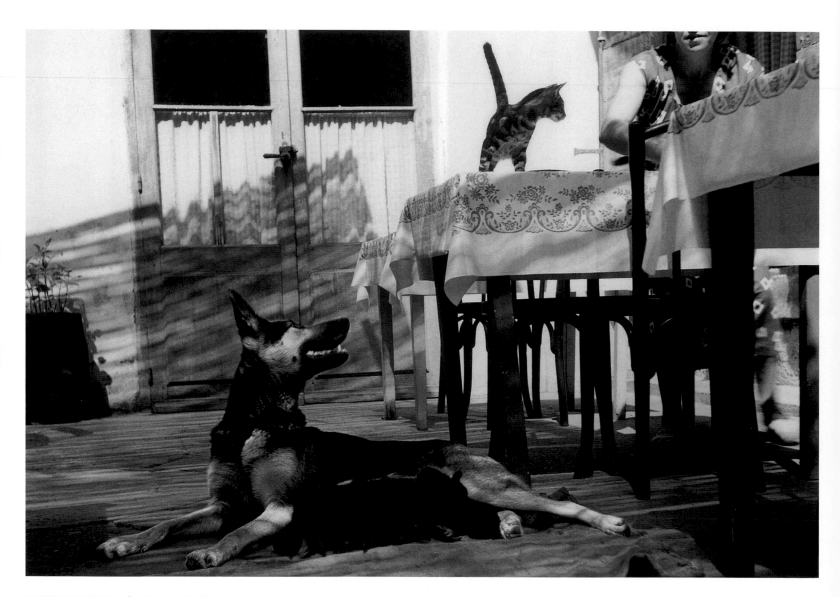

LUCIEN CLERGUE, Arles, France, 1958

Lucien Clergue was an intimate of Picasso—his daughter's godfather—and Cocteau. He is known for his poetic recording of van Gogh landscapes and Camargue marshlands. His photography revolves around portraiture—ranging from world-renowned personalities to the gypsies of Provence—bull fights; rolling sandy beaches, often with sensuous nudes; and American deserts. "I've always been attracted to cats. I'm impressed by them and find them mysterious," admitted Clergue. On photographing cats, he added: "I regret that cats are disappearing from the streets of Arles. Perhaps when I decide to retire, I'll spend my days in the Roman amphitheater looking around, making friends with them and taking their pictures."

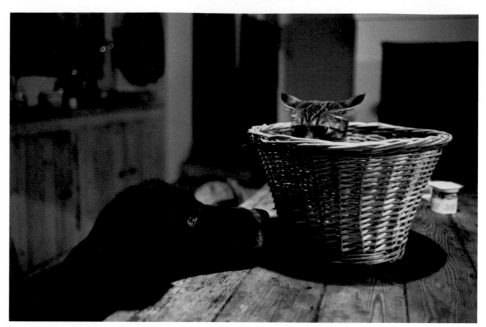

Top: RICHARD KALVAR,
Saint-Emilion, Gironde,
Aquitaine, France, 1977

Bottom:
ERGY LANDAU,
Cat to Go, 1930

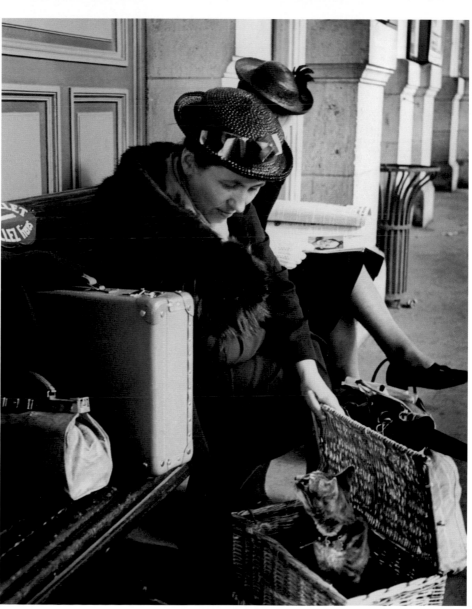

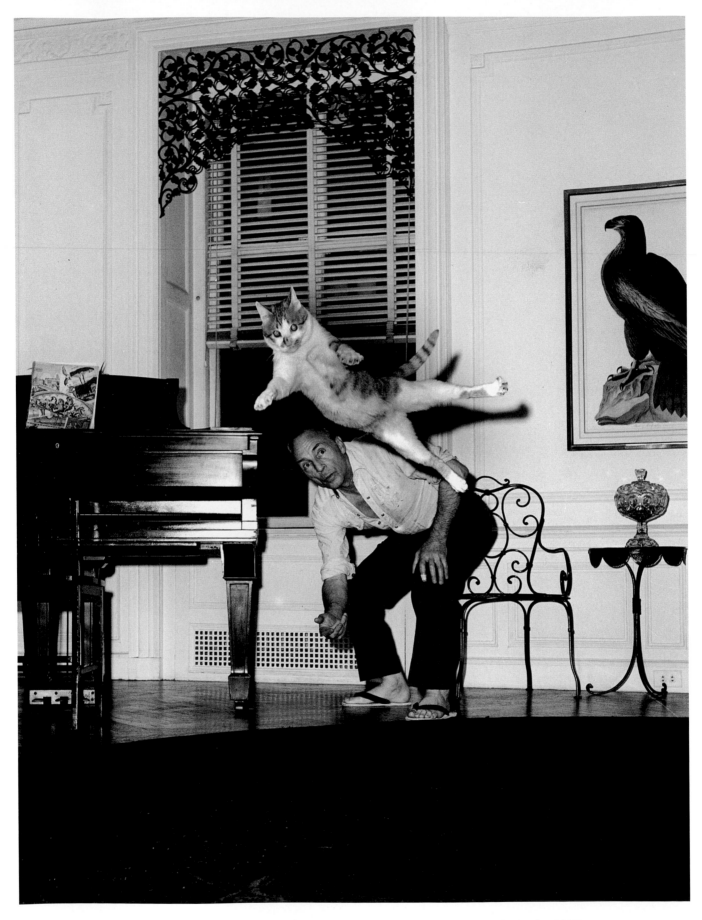

MARTHA SWOPE, Choreographer Georges Balanchine with Mourka, 1965

HANS SILVESTER, *Pas de deux*, Amorgos, Greece, 1996
The undisputed master of cat photography, Hans Silvester lives in a Provençal hamlet, with five families and more cats than people. His own is called Gris-Gris, the most common of French cat names. A children's book on squirrels published over forty years ago marked the start of his photographic career dedicated to nature, ecology, and animals. Widely known for his photos of Greek island cats, Silvester recalled how this came about: "During an ecological assignment on the islands in the eighties, I was struck by the way cats were living so harmoniously with people. And not single cats, but groups. Their behavior and way of life fascinated me. The villagers fed them and, in return, expected them to kill the mice that devoured the stored winter grain, just as in Egyptian times. But they were not pets and never entered their homes. Since then, I've gone back so often that the cats recognize my voice. They know that I like them, but I never touch them or come too close with my camera. After missing a year, when I came back and greeted them with a big 'hello,' you could tell they were happy to see me. There was a lot of purring. You have to know them to photograph them."

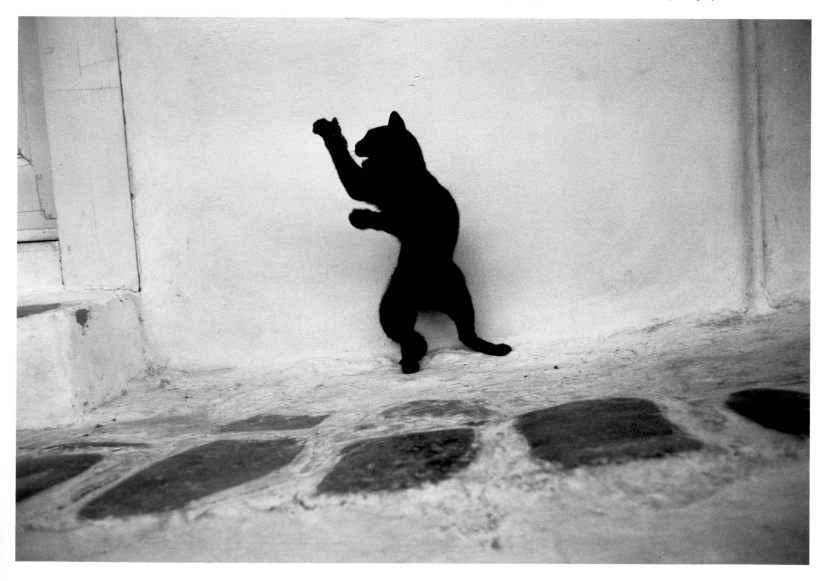

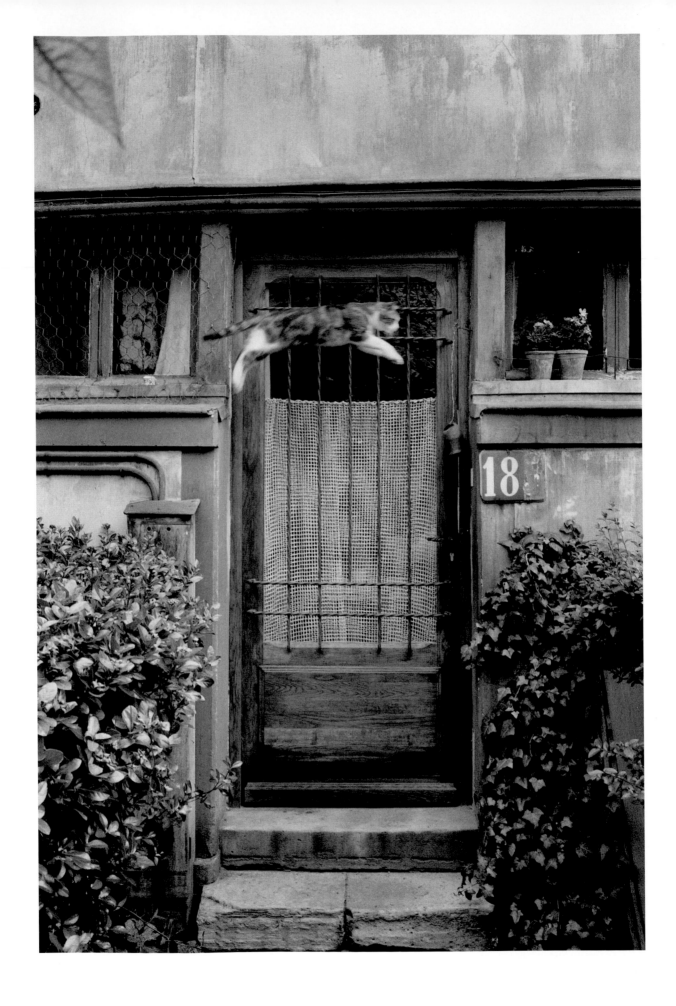

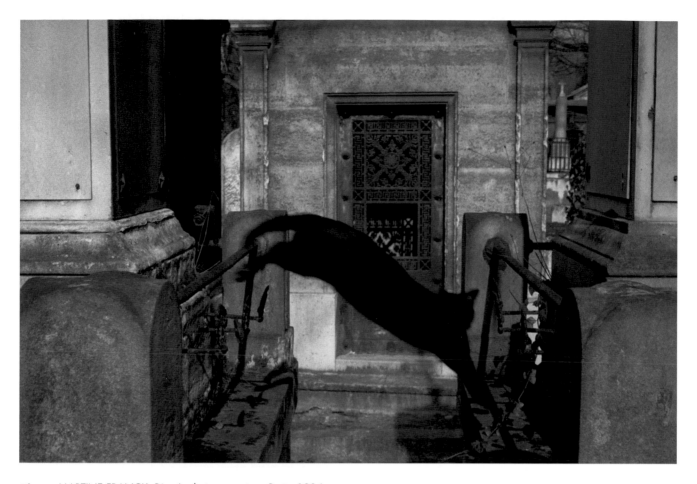

Above: MARTINE FRANCK, Père Lachaise cemetery, Paris, 1984

Facing page: HERVÉ GLOAGUEN, *Cité Fleurie*, boulevard Arago, Paris, 1972
Passionate about jazz and the arts, Hervé Gloaguen has photographed top performers and famous painters everywhere. Gloaguen, who was born a Breton, is in love with his adopted Paris and follows its society, evolution, and struggles with his camera. Regarding the photo featured in this book, he said, "The leaping cat was taken in 1972, during a demonstration to protest against a project to demolish an artists' quarter on the boulevard Arago. That day, many Parisians came to defend this small area, where poets and artists, both known and unknown, had their homes and ateliers. Neighborhood cats also participated in this protest."

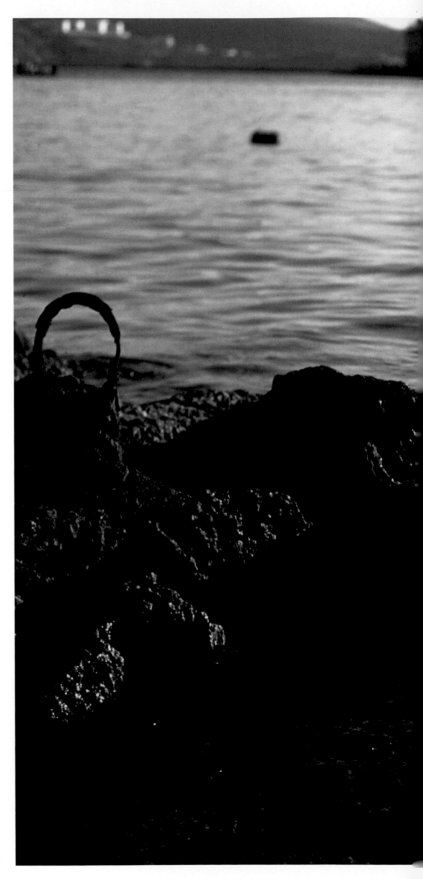

HANS SILVESTER, Milos, Greece, 1994

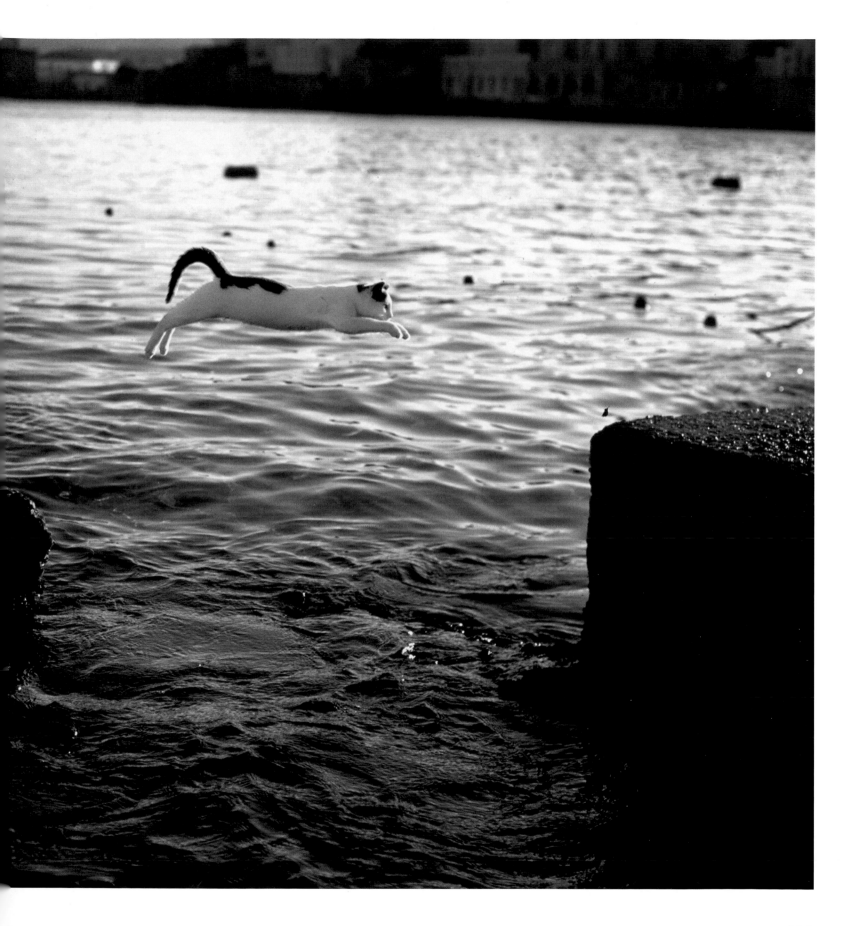

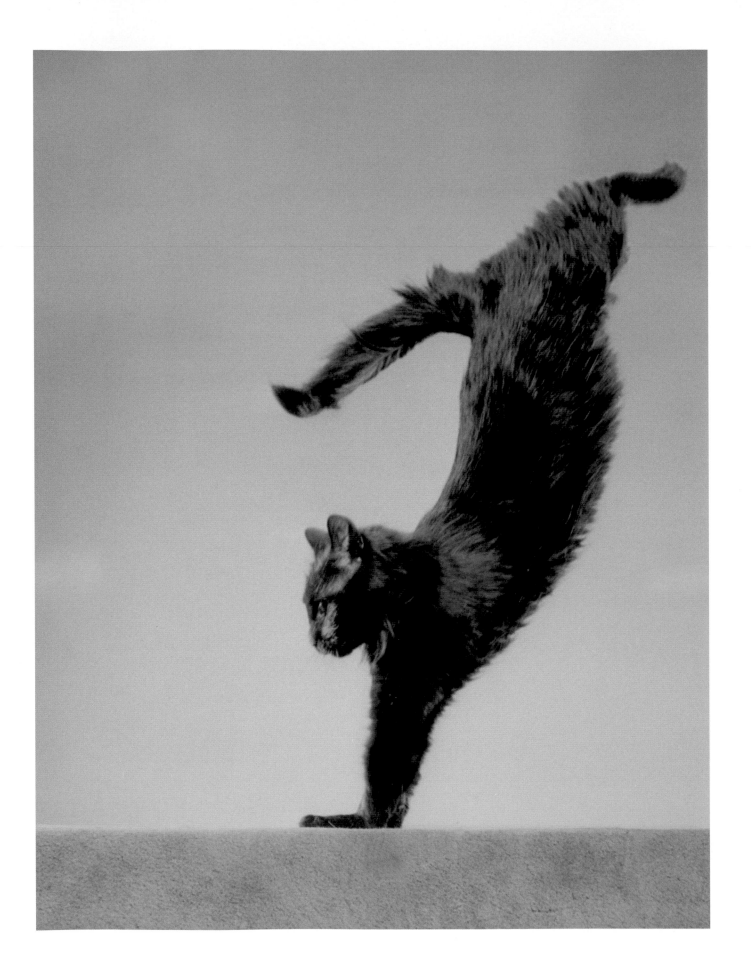

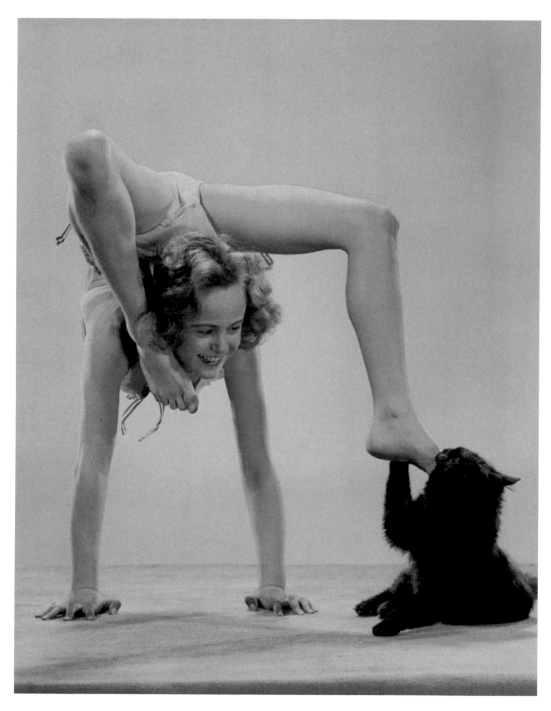

Above: GJON MILI, Blackie nibbling on an acrobat's toe, New York, 1943

Facing page: GJON MILI, Blackie does a "pawstand" to get attention, New York, 1943
Gjon Mili's cat, Blackie, was always in the studio, acting up and stealing the show from the myriad of visitors,
including performers and well-known personalities who came to be portrayed by the prominent *Life* photographer.

VICs (Very Important Cats)

THESE ARE NO ORDINARY CATS, FAMOUS FOR THE COMPANY THEY KEPT—ARTISTS, WRITERS, MUSICIANS, FILMMAKERS, DANCERS, AND SINGERS. COLETTE COULDN'T PEN A WORD WITHOUT HER MUSES CROWDING AROUND HER HAND. IN HIS PAINTINGS OF NYMPHETS, BALTHUS PORTRAYED HIS FELINE PETS AS SYMBOLS OF SENSUALITY. THE WRITER LÉAUTAUD GATHERED THREE HUNDRED STRAYS DURING HIS LIFETIME AND BURIED THEM ALL IN HIS GARDEN. JAMES DEAN LOVED THEIR PRANKS. AWARE OF THEIR IMPORTANCE, THESE FOUR-LEGGED CELEBRITIES OFTEN STEAL THE SPOTLIGHT AND UPSTAGE THEIR ILLUSTRIOUS MASTERS BEING PHOTOGRAPHED. AFTER ALL, THEY ARE *VERY IMPORTANT CATS*.

SANFORD ROTH, Anna Magnani with Louis XIV
Magnani was a *gattofila* devoted to the hordes of neighborhood cats in Rome's Torre Argentina temples, where they prowled long before Julius Caesar was stabbed there by Brutus in 44 B.C.E.

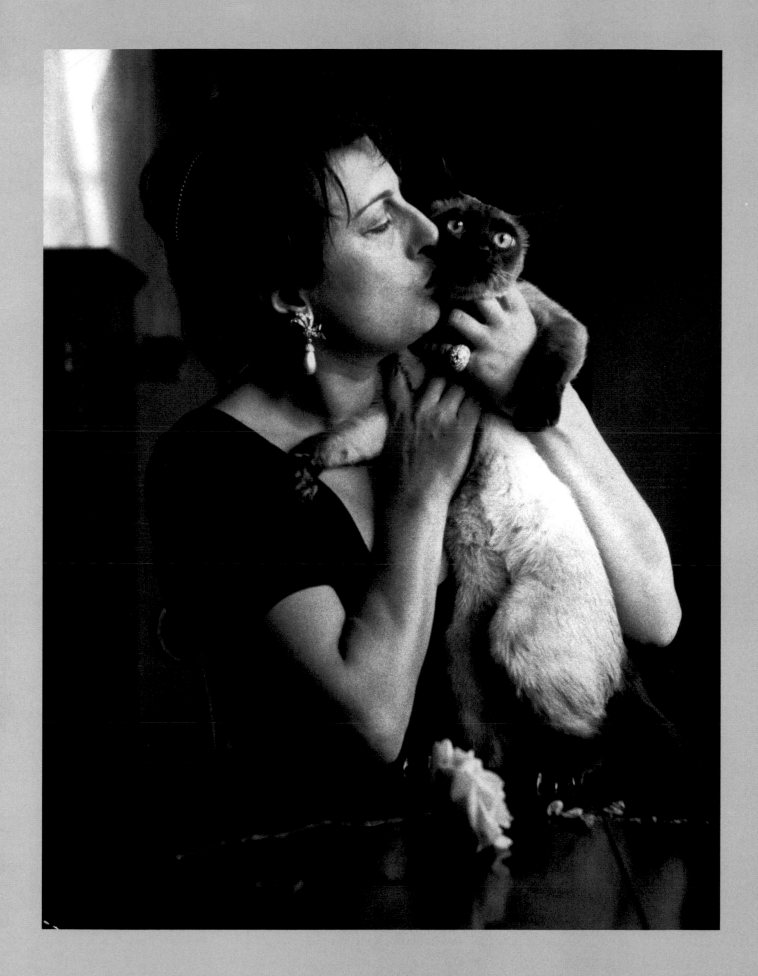

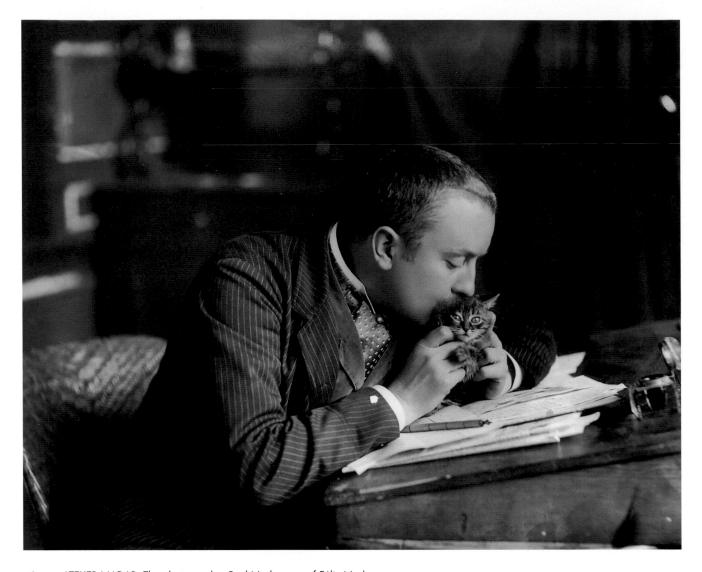

Above: ATELIER NADAR, The photographer Paul Nadar, son of Félix Nadar
After taking over the family atelier around 1886, Paul Nadar specialized in theatrical and fashion photography, portraits of aristocrats, and undertook major international reportages. The Nadars were credited with the first photo-reportage, with Félix as the photographer and Paul as the interviewer.

Facing page: MAN RAY, Surrealist painter Georges Malkine, Paris, c. 1929
Born Emmanuel Rudnitsky, Man Ray was given his more familiar name at fifteen by his parents, who insisted that he use it. Cubist, Dadaist, Surrealist—Man Ray was all of these. Continually experimenting, unconcerned with technique, he created cameraless photos, by placing an object on photographic paper and exposing it to light. These he called "Rayographs," coining the term for this technique on which his own work was based.
As a painter, sculptor, photographer, and filmmaker, he combined his talents to create "disturbing objects."
He achieved international fame between the wars as the photographer of Parisian artists, intellectuals, and writers.
He fled Europe during the Nazi occupation and settled in Hollywood, where he resumed painting.

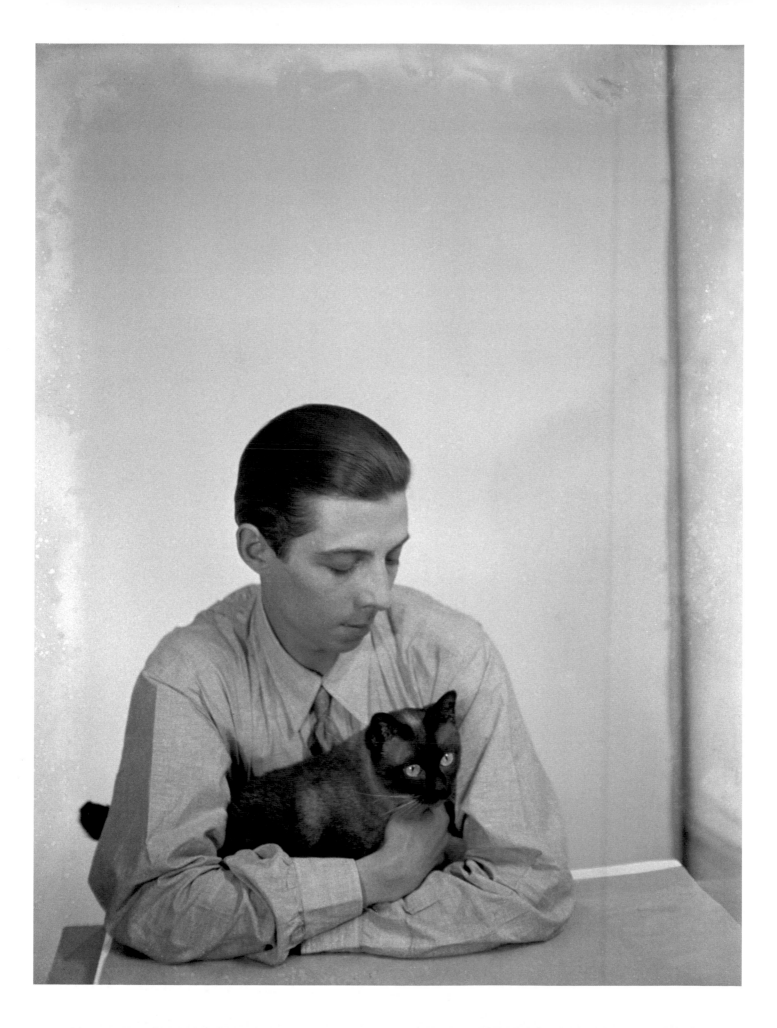

ROBERT DOISNEAU, Paul Léautaud, 1953

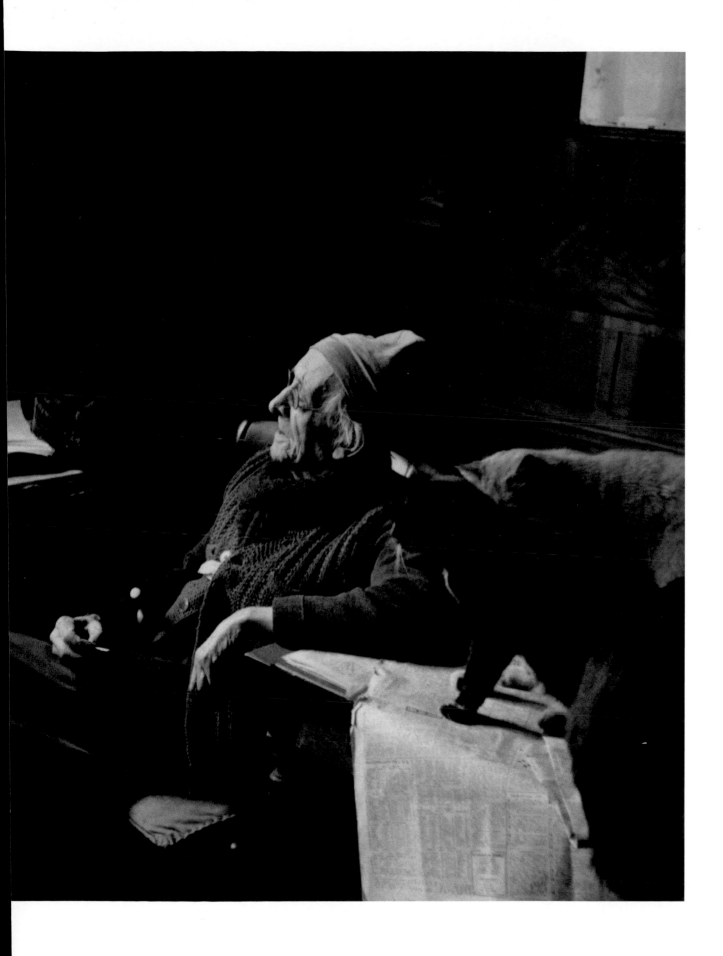

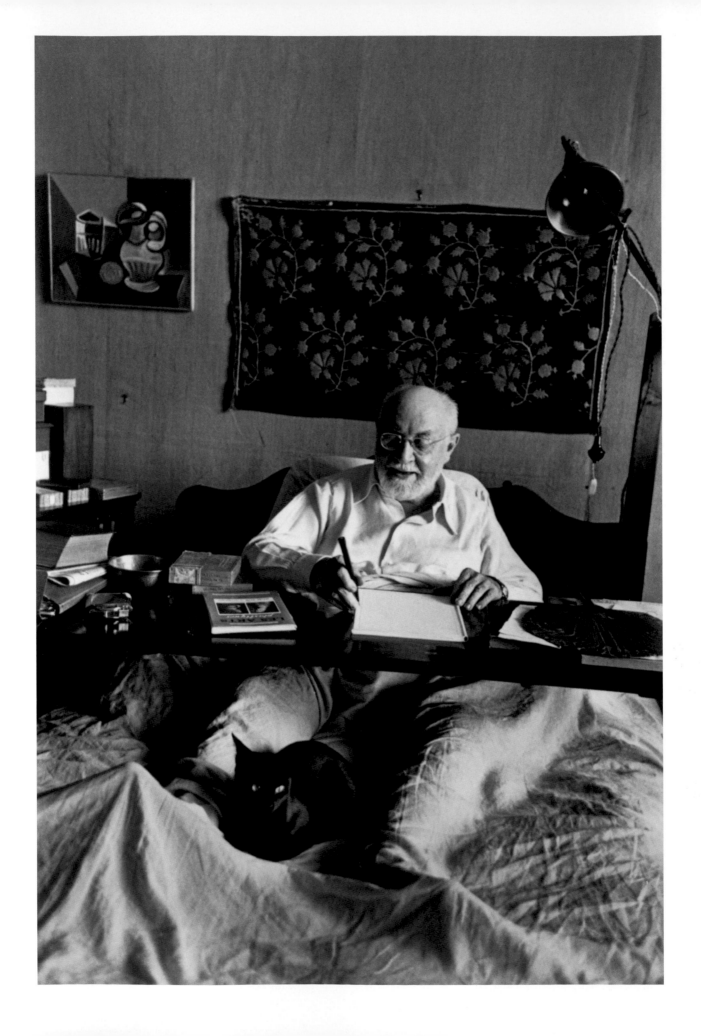

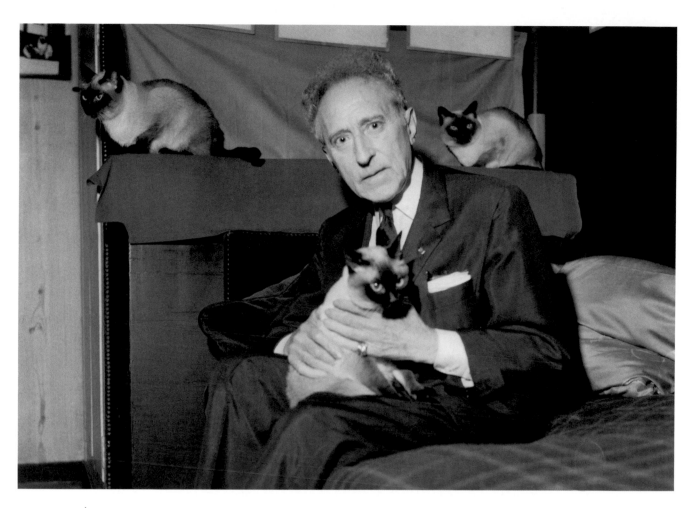

Above: HERVÉ GLOAGUEN, Jean Cocteau in his Palais Royal apartment, Paris, 1962

Facing page: ROBERT CAPA, Henri Matisse in his Hôtel Regina apartment, Nice, France, 1949

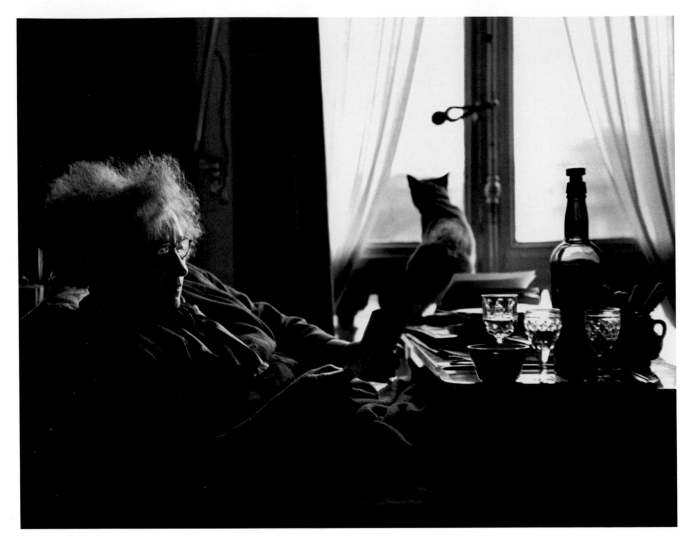

Above: SANFORD ROTH, Colette with Louis XIV, Paris, 1950

Facing page: SANFORD ROTH, Blaise Cendrars with Louis XIV, 1950
Sanford Roth, an expatriate American in post-war Paris, could have had as his motto, "Have cat, will travel," since he took his pet feline,
Louis XIV, along to feature in double portraits with the most prominent writers, actors, and painters on the intellectual and artistic scene.
Life sent him to Hollywood as their specialized cinema photojournalist. As a close friend of James Dean, "Sandy" photographed
the rebellious star on and off the set of *Giant*, and accompanied him on the 1955 trip that ended with Dean's fatal crash in his Porsche
Spyder. Roth witnessed the accident and photographed the aftermath.

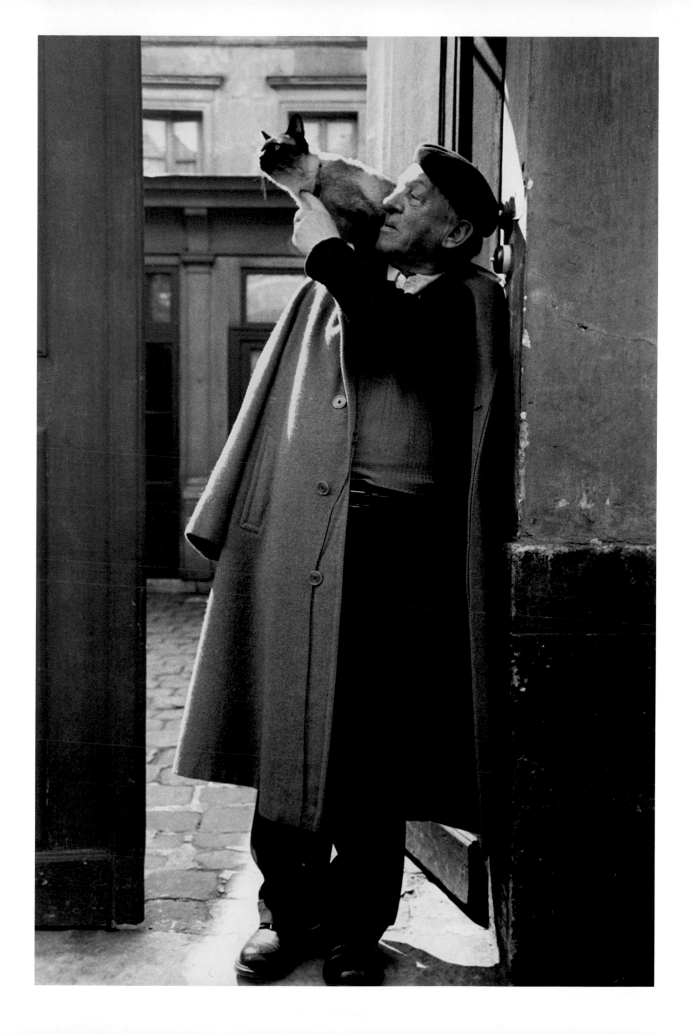

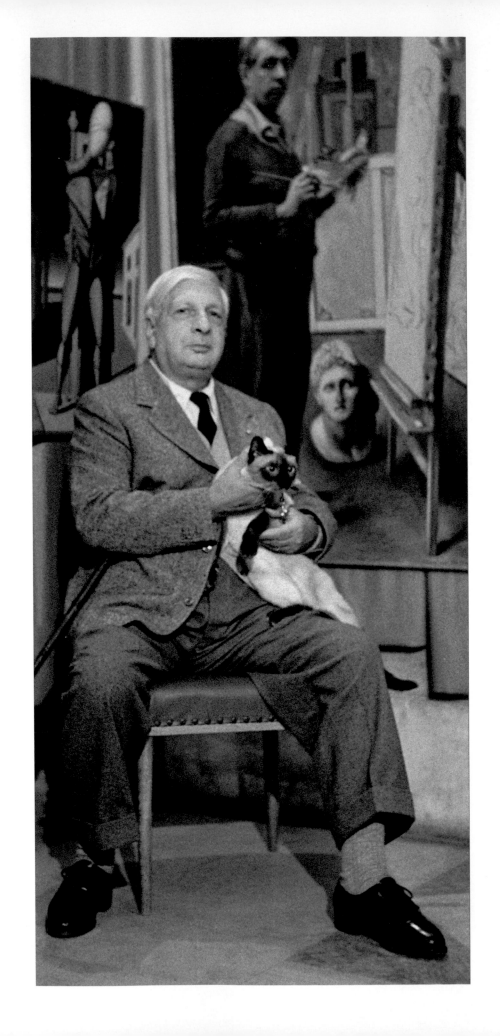

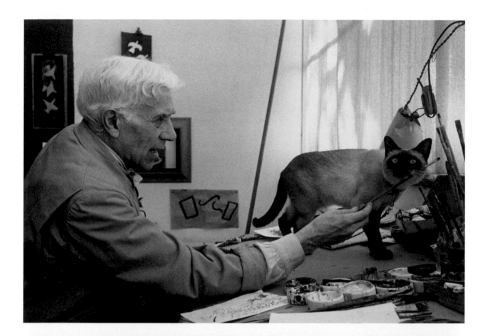

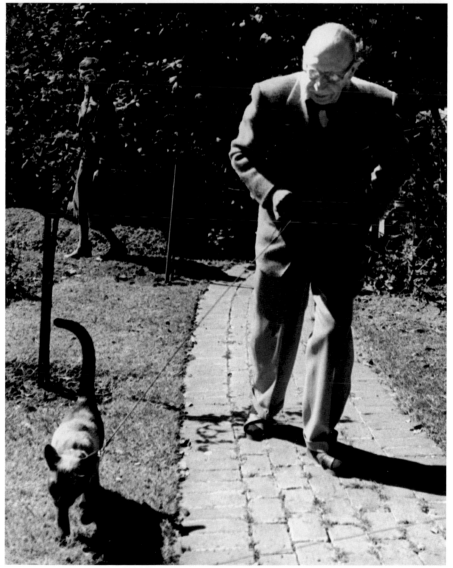

Left: SANFORD ROTH, Georges Braque with Louis XIV, 1950

Left: SANFORD ROTH, Igor Stravinsky with Louis XIV, 1950

Facing page: SANFORD ROTH, Giorgio de Chirico with Louis XIV, 1950

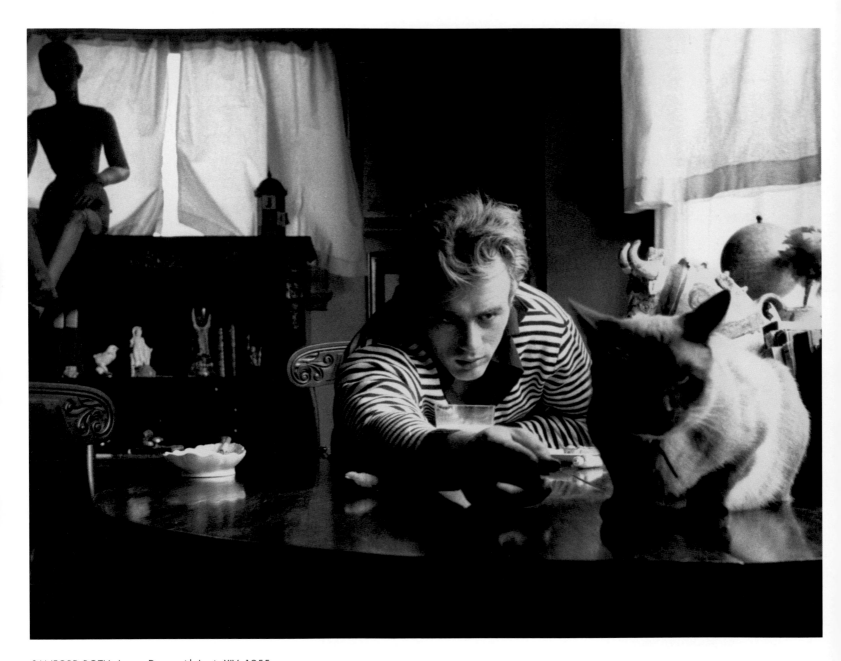

SANFORD ROTH, James Dean with Louis XIV, 1955

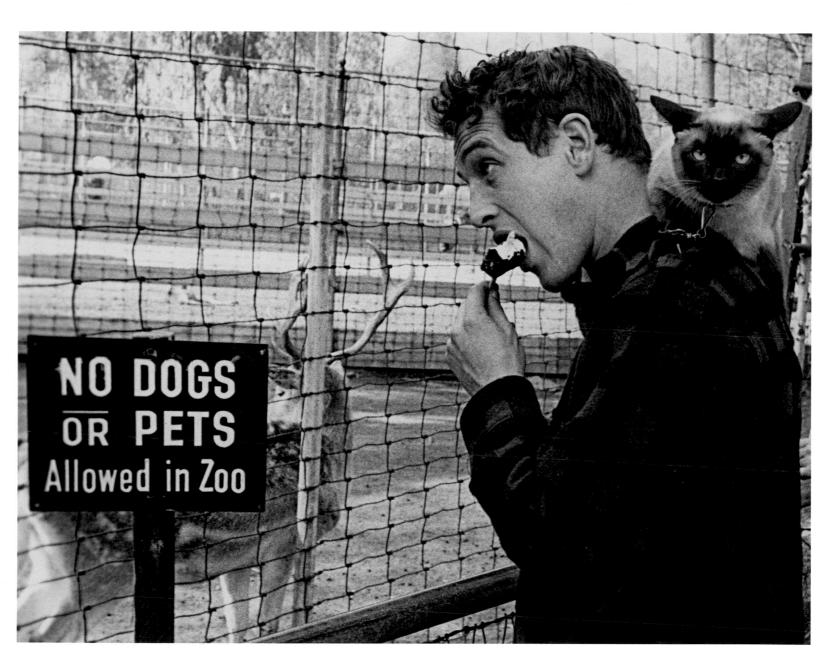

SANFORD ROTH, Paul Newman with Louis XIV, c. 1957

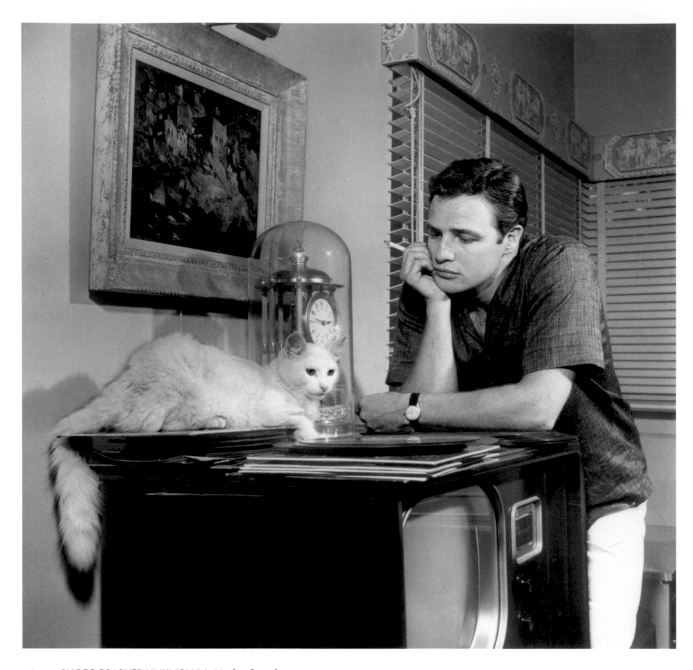

Above: PHOTOGRAPHER UNKNOWN, Marlon Brando

Facing page: LARRY BURROWS, T.S. Eliot, London, 1958
The British author's cat was the inspiration for *Old Possum's Book of Practical Cats*,
later to become the Broadway hit musical *Cats*.

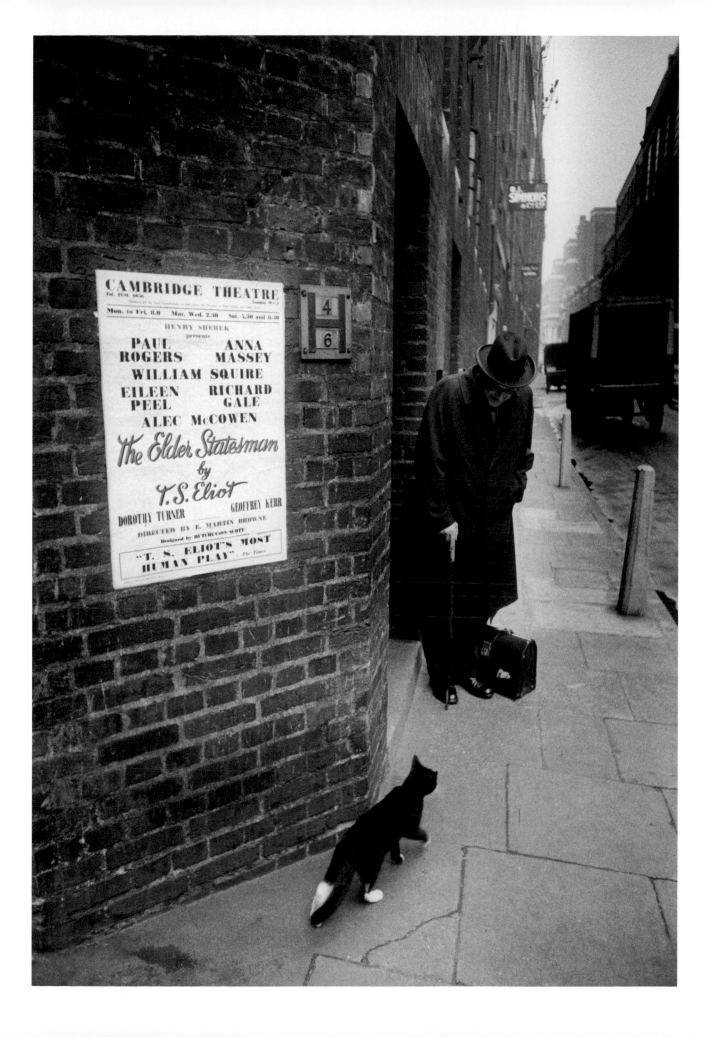

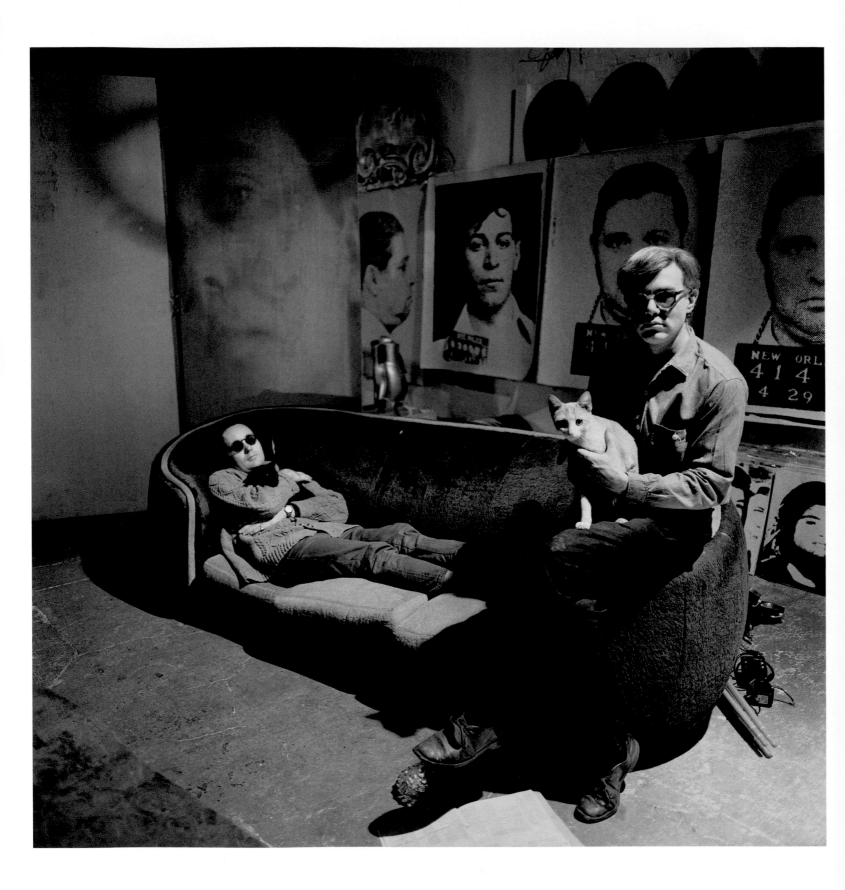

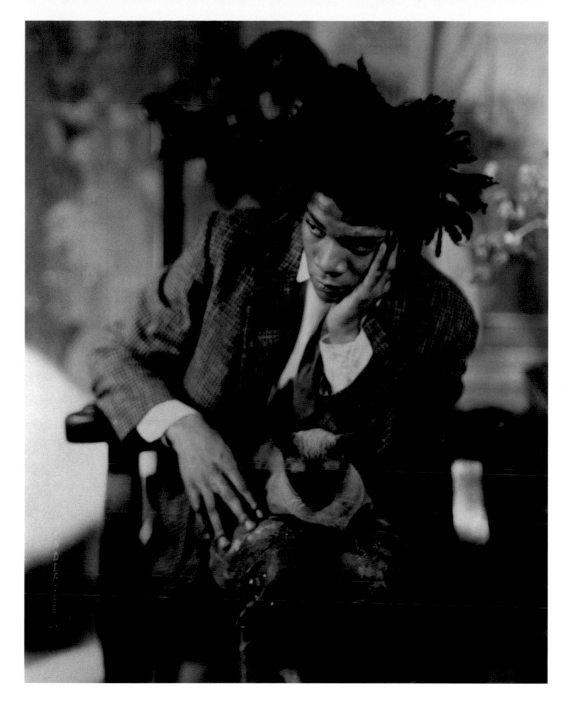

Above: JAMES VAN DER ZEE, Jean-Michel Basquiat, New York, 1982

Facing page: BRUCE DAVIDSON, Pop artists Andy Warhol and Robert Indiana, New York, 1964
Bruce Davidson has documented urban life throughout the years, with a succession of photographic essays about New York youth, a Brooklyn gang, an East Harlem neighborhood, the subway, and aspects of life in Central Park. His photos of the civil rights movement in the U.S. are particularly memorable. "In 1964, I was asked by *Vogue* to photograph Andy Warhol in his studio. At that time, I was unaware of how famous he was. I thought it strange that Warhol did not speak. He and the artist Robert Indiana poised themselves in such a way that made me feel they were performing for the camera, and creating an image of themselves for the magazine. I was looking for something more candid and authentic." Davidson also commented: "I have always liked large cats because when I am photographing on the street, I move and think like one stalking its prey in the jungle. Little cats make me feel like I am going to itch and sneeze."

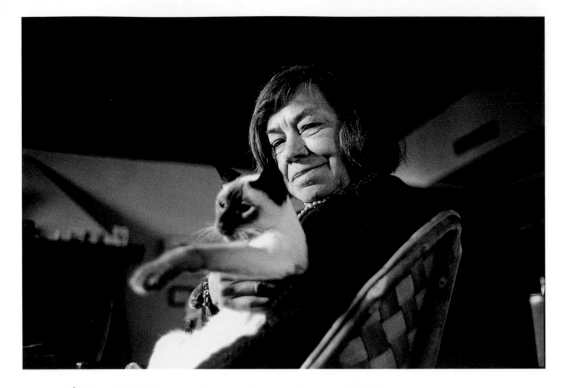

Above: GÉRARD RONDEAU, Patricia Highsmith, Locarno, Switzerland, 1985
Rondeau uses a small, well-worn Leica and only natural light. "In the dark, I just wait for the right light to pass through," he says. The French newspaper *Le Monde* has published many of his numerous portraits of artists and writers; here, his portrait of the expatriate American author Patricia Highsmith, internationally renowned for her enthralling novels inspired by her many cats. In collaboration with Médecins Sans Frontières (Doctors without Borders), Rondeau photographed the war in Bosnia and the refugee camps. He explained, "During bad times, it is important to be with the people."

Facing page: MARTINE FRANCK, Diego Giacometti at home, Paris, 1985
Martine Franck—famous for her sensitive portraits expressing warmth and understanding of her subjects—remarked, "It is easier for me to photograph someone when he has an animal." This was reflected in her series of artists such as Balthus and Diego Giacometti, who had their pet cats with them during the photo sessions. In sharp contrast are her gripping images of elderly women desperately clutching their cats. She took these during the years when she worked as a volunteer for les petits frères des Pauvres (Little Brothers of the Poor), an organization to help the elderly and those in need.

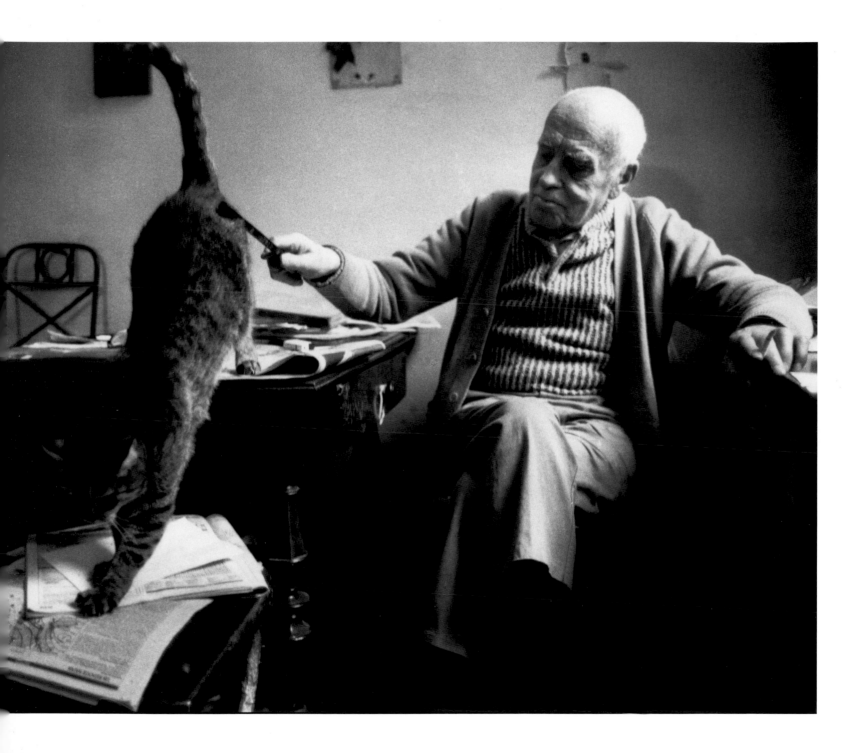

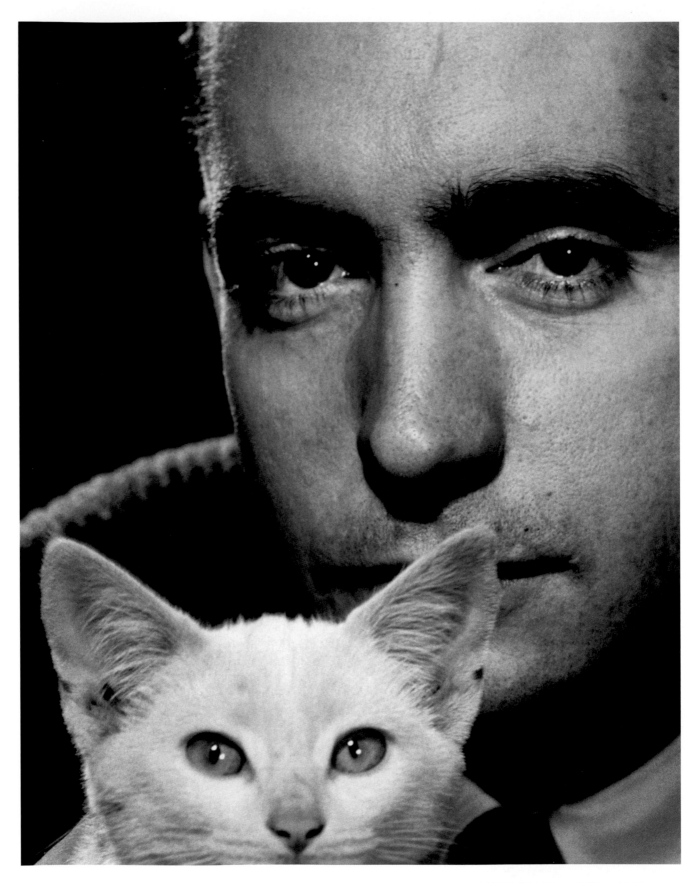

PHILIPPE HALSMAN, Edward Albee, 1961

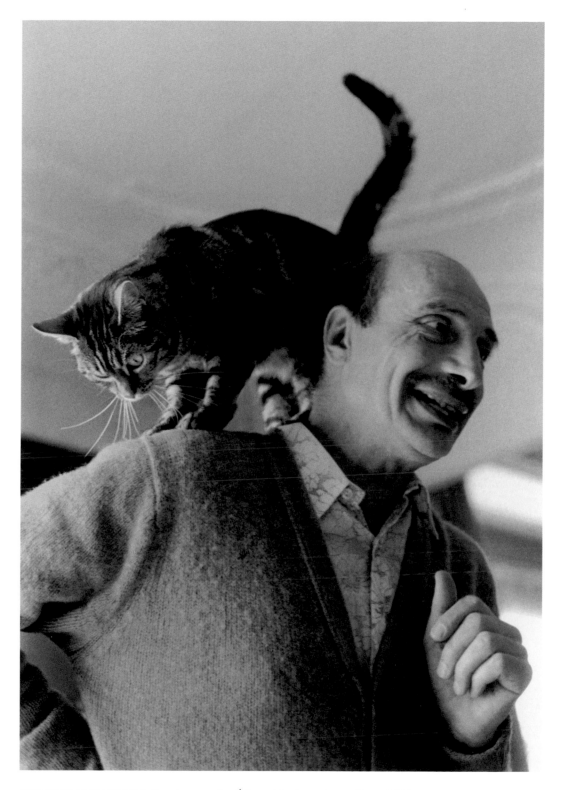

FRANÇOIS LE DIASCORN, The photographer Édouard Boubat at home, Paris, 1990
François Le Diascorn found his friend and colleague very cat-like in temperament. "He was slender,
independent, supple, even mystical. When I photographed him, it seemed very fitting to have his cat
clambering over his shoulders."

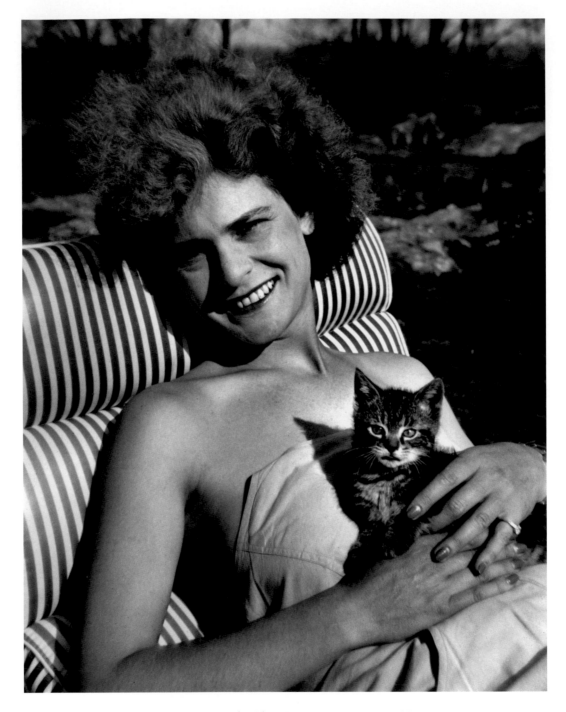

Above: ALFRED EISENSTAEDT, Margaret Bourke-White, Darien, Connecticut, 1944

Hailed as the "father of photojournalism," Eisenstaedt was known as the master of the candid photograph. In 1935, he moved from West Prussia to America and acquired a Rolleiflex. A year later, he became one of the original staff photographers for *Life* magazine and over the following thirty years, he shot eighty-six of the magazine's covers. He favored the Rolleiflex because he could take a picture without raising the camera to his eye, allowing him to click away unobtrusively. When Eisenstaedt was in Times Square on August 15, 1945 for the V-J Day (Victory over Japan) celebrations marking the end of World War II, he snapped a sailor sweeping a nurse off her feet in a deep embrace—the photo for which he is probably now most well known. "Eisie," as he was nicknamed, was satisfied with this enduring image: "People tell me that when I am in heaven, they will remember that picture." Eisenstaedt was the second staff photographer for *Life* magazine. The first, his friend Margaret Bourke-White, was also the first female war photographer, covering World War II.

Facing page: SANFORD ROTH, Audrey Hepburn and Mel Ferrer visiting a cat colony in Rome, 1950

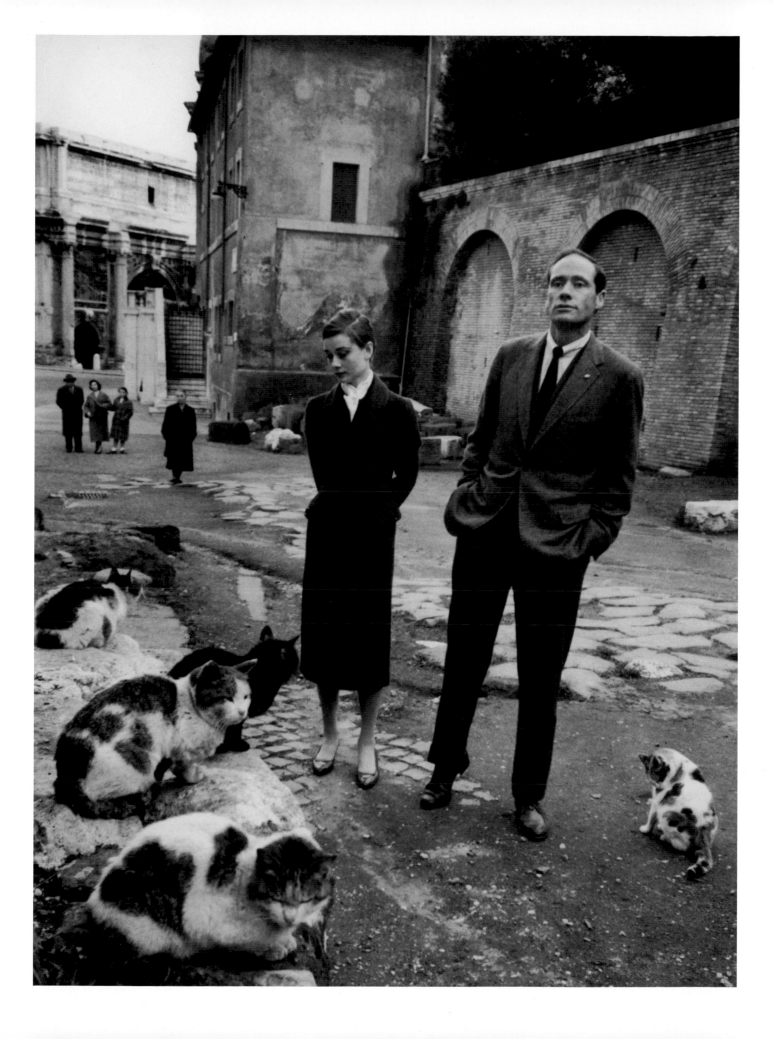

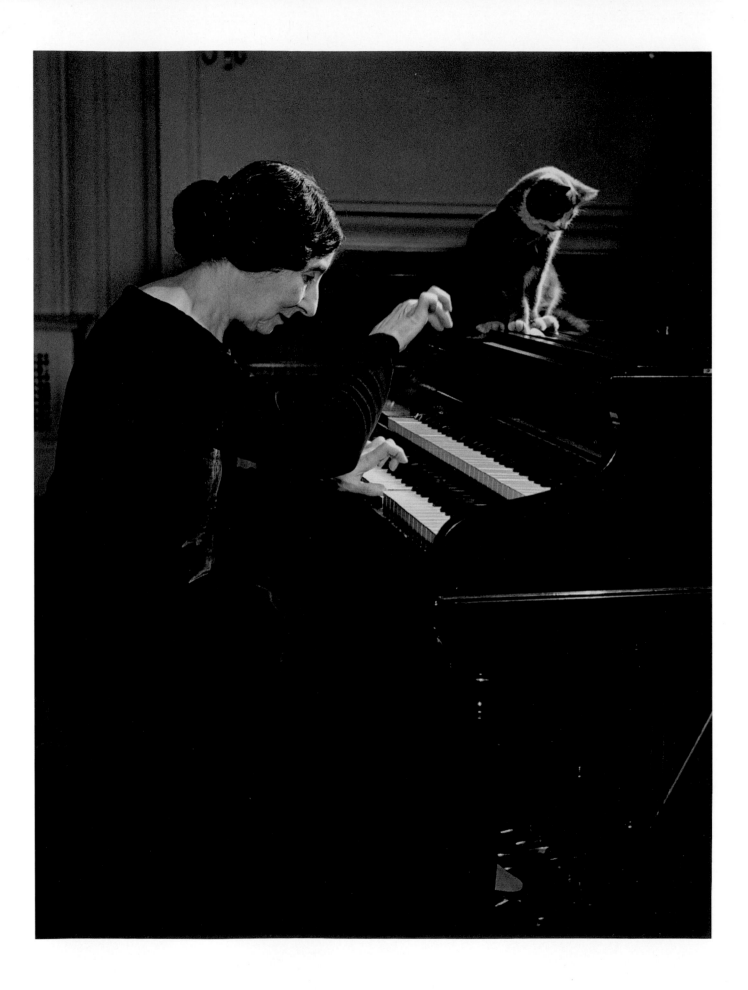

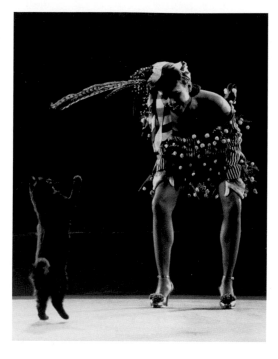

Above: GJON MILI, Choreographer Katherine Dunham, dancing with Blackie, 1943

Facing page: PHILIPPE HALSMAN, Harpsichordist Wanda Landowska, 1944

ACKNOWLEDGMENTS

I would particularly like to thank Joanna Steichen; Donna Van Der Zee; Sir Elton John; Professor Herbert Molderings, Phyllis Umbehr and Galerie Kicken; Sylvie Languin; Irene Attinger and Henri Coudoux, Maison Européen de la Photographie; Françoise Jacquot; Jane Jackson; Bobbi Burrows and Pryor Dodge.

My deep appreciation to Christophe Mauberret, Patrimoine Photographique; Charles-Antoine Revol, Donation Jacques-Henri Lartigue; Isabelle Pantanacce and Hervé de Gand, Centre des Monuments Nationaux; Sophie Rochard-Fiblec, Raphaëlle Cartier, Pierrick Jan, and Philippe Couton, Réunion des Musées Nationaux; Cynthia Young, International Center of Photography, New York; Amy Densford, Hirschhorn Museum and Sculpture Garden, Smithsonian Institution; Sue Daly and Jocelyn Phillips, Sotheby's London; Dominque de Font-Reaulx and Joëlle Bolloch, Musée d'Orsay; Laure Beaumont-Maillet, Monique Moulène, and Evelyne Brejard, Bibliothèque Nationale de France; Annyck Graton, Centre Pompidou; Alessandra Corti, Alinari Picture Library; François Cheval, Musée Nicéphore Niépce; and Laurie Winfrey, Carousel Research.

My thanks to the many photographers everywhere who helped in my quest for photos and information to make this book possible, and to the photo agencies that searched and found so many lesser-known images. Marie-Christine Biebuyck and Marco Barbon, Magnum Photos; Kathleen Grosset and Aude Huteau, Rapho; Anouck Baussan and Linda Ruzicic, Getty Images; Françoise Carminati, Corbis/Bettman Archives.

I want to express my gratitude to the dedicated Flammarion team, whose conviction that this would become a superb book encouraged me throughout: Aurélie Sallandrouze for her daily involvement, Sylvie Ramaut. A very special thank you to Ghislaine (Gisou) Bavoillot, who masterminded the whole project.

To my wife, Barbara, with appreciation for your incredible support, assistance, and encouragement through the development and realization of this book.

The publisher wishes to thank Karen Bowen for her talent and her patience and David Costello-Lopes and Caroline Mauduit for their enthusiastic help.

PHOTOGRAPHIC CREDITS

Cover © Yann Arthus-Bertrand: Balinais Alégrias Casa Decano, from the collection of M. and Mme Ferenczi, p. 1 © Édouard Boubat/Rapho, p. 2 © Bruce Davidson/Magnum Photos, p. 3 © Martine Franck/Magnum Photos, pp. 4–5 © Elliott Erwitt/Magnum Photos, p. 7 Duncan, p. 8 © Photograph J.H. Lartigue © Ministère de la Culture, France/AAJHL, p. 11 Félix Nadar, © Photo RMN/© photo Hervé Lewandowski, p. 12 Umbo, Phyllis Umber/Gallery Kicken Berlin, p. 15 with the permission of Cecil Beaton Studio Archive, Sotheby's, p. 23 © Henri Cartier-Bresson/Magnum Photos, p. 24 © Photograph J.H. Lartigue © Ministère de la Culture, France/ AAJHL, p. 25 Charles Augustin Lhermitte © Photo RMN/© Hervé Lewandowski, p. 26 © Ville de Chalon-sur-Saône, France, Musée Nicéphore Niépce, p. 26 © Ville de Chalon-sur-Saône, France, Musée Nicéphore Niépce, p. 27 © Photo RMN/© René-Gabriel Ojéda/© Edward Steichen/ Carousel Research, with the permission of Joanna T. Steichen, p. 29 Requillart © Ministère de la Culture, p. 29 © Elliott Erwitt/Magnum Photos, pp. 28–29 © Édouard Boubat/Top-Rapho, p. 30 © Marc Riboud, p. 31 © Jean-Philippe Charbonnier/Rapho, p. 32 © Une opiomane endormie (A Sleeping Opium Addict), 1931, © ESTATE BRASSAÏ/R.M.N./© Michèle Bellot, p. 33 © Getty Images/Weegee, p. 34 © Henri Cartier-Bresson/Magnum Photos, p. 35 © Janine Niépce/Rapho, p. 36 © J.K./Magnum Photos, p. 37 © Pierre Bérenger/Rapho, p. 38 © Francis Stoppelman/Rapho, p. 38 © Willy Ronis/Rapho, p. 39 Chat se regardant dans la glace, c. 1946, © ESTATE BRASSAÏ/R.M.N., p. 40 © Sabine Weiss, p. 41 © Cornell Capa Photo by Robert Capa 2001/Magnum Photos, p. 42 Ylla © 2005 Pryor Dodge, p. 43 © Édouard Golbin, p. 45 © Yann Arthus-Bertrand, Somali: Hyacinth des Fauve et Or, property of Mme Christine Le Renard, p. 46 © Edward Steichen/© Carousel Research with the permission of Joanna T. Steichen, p. 47 © Donna Mussenden Van der Zee, Library of Congress, Prints and Photographs Division, photograph by James Van der Zee, p. 48 Charles Hugo, © Photo RMN/© Hervé Lewandowski, p. 49 Frank Eugene, © Photo RMN/© Hervé Lewandowski, p. 50 Moholy-Nagy, © ADAGP, Paris 2005, p. 51 Wanda Wurtz, © Fratelli Alinari Museum of the History of Photography-Zannier Collection, Florence, p. 52 © Photo CNAC/MNAM dist. RMN/© Jacques Faujour MAN RAY/ADAGP, Paris 2005, pp. 52–53 © Ariane, p. 54 © Eakins, © Hirshhorn Museum & Sculpture Garden, Smithsonian Institution, transferred from Hirshhorn Museum and Sculpture Garden Archives May 24, 1983. Photographer: Lee Stalsworth., p. 55 © Denis Brihat/Rapho, pp. 56–57 © Bruno Bourel/Rapho, p. 58 © Robert Doisneau/Rapho, p. 59 © Fernando Sciana/Magnum Photos, p. 60 photograph by courtesy of Cecil Beaton Studio Archive, Sotheby's, p. 61 © Janine Niépce/Rapho, p. 62 © Yann Arthus-Bertrand, Siamois: Hugo de la Pergola, property of Mme Jacqueline Pierre, p. 63 © Yann Arthus-Bertrand, Somali: Hyacinth des Fauve et Or, property of Mme Christine Le Renard, p. 65 © Leonard Freed/Magnum Photos, pp. 66–69 André Kertész © Ministère de la Culture, France, p. 70 © ATGET, p. 71 © Raymond Voinquel, Patrimoine Photographique, p. 72 © Bovis, Patrimoine Photographique, p. 73 © Henri Cartier-Bresson/Magnum Photos, p. 74 © Photograph J.H. Lartigue © Ministère de la Culture, France/AAJHL, p. 74 © Robert Doisneau/Rapho, p. 75 © Wu Jia Lin, p. 76 © Bettmann/CORBIS, p. 77 © Richard Kalvar/Magnum Photos, p. 78 © Marc Riboud, p. 79 © Janine Niépce/Rapho, pp. 80–81 © Jean Dieuzaide/Rapho, p. 82 photography © Marie Babey, p. 83 © Maurice Zalewski/Rapho, p. 84 Ylla © 2005 Pryor Dodge, p. 85 © Henri Cartier-Bresson/Magnum Photos, p. 86 © Robert Doisneau/Rapho, p. 87 © Willy Ronis/Rapho, p. 88–89 © François Le Diascorn/Rapho, p. 89 © François Le Diascorn/Rapho, p. 90-91 © Robert Doisneau/Rapho, p. 91 Lalique, © Photo RMN/© Hervé Lewandowski, p. 92 © Ariane, p. 93 © Lane-A.F. Low/Rapho, p. 93 André Kertész © Ministère de la Culture, France, p. 95 © Ylla/Rapho, p. 96-97 E. Muybridge, © Photo RMN/© Rights reserved, p. 99 © Photograph J.H. Lartigue © Ministère de la Culture, France/AAJHL, p. 98 Bonnard, © Photo RMN/© Rights reserved, p. 100 © Keystone/Rapho, p. 100 Barrera © Bettmann/CORBIS, p. 101 Germeshausen © Bettmann/CORBIS, p. 102–103 © Philippe Halsman/Magnum Photos, p. 104 © Sabine Weiss, p. 105 © Pierre Putelat/Janaca/Hoa Qui, p. 105 © Hans Silvester/Rapho, p. 106 © Ylla/Rapho, pp. 106–107

© Elliott Erwitt/Magnum Photos, p. 108 © Lucien Clergue, p. 109 © Richard Kalvar/Magnum Photos, p. 109 © Ergy Landau/Rapho, p. 110 © Martha Swope, p. 111 © Hans Silvester/Rapho, p. 112 © Hervé Gloaguen/Rapho, p. 113 © Martine Franck/Magnum Photos, pp. 114–115 © Hans Silvester/Rapho, p. 116 © Getty Images/Gjon Mili, p. 117 © Getty Images/Gjon Mili, p. 119 © Sandford H. Roth/Rapho, p. 120 Paul Nadar, atelier Nadar, © Centre des monuments nationaux, Paris, p. 121 © photo CNAC/MNAM Dist. RMN/© Rights reserved/ MAN RAY TRUSR/ADAGP, Paris 2005, pp. 122–123 © Robert Doisneau/Rapho, p. 124 © Cornell Capa Photos by Robert Capa 2001/Magnum Photos, p. 125 © Hervé Gloaguen/Rapho, p. 126 © Sanford H. Roth/Rapho, p. 127 © Sanford H. Roth/Rapho, p. 128 © Sanford H. Roth/Rapho, p. 129 © Sanford H. Roth/Rapho, p. 129 © Sanford H. Roth/Rapho, p. 130 © Sanford H. Roth/seita Ohnishi/Rapho, p. 131 © Sanford H. Roth/seita Ohnishi/Rapho, p. 132 Anonyme © Photofest, p. 133 © Larry Burrows, p. 134 © Bruce Davidson/Magnum Photos, p. 135 © Donna Mussenden Van der Zee, p. 136 Rondeau, p. 137 © Martine Franck/Magnum Photos, p. 138 © Philippe Halsman/Magnum Photos, p. 139 © François Le Diascorn/Rapho, p. 140 © A. Eisenstaedt/International Center of Photography collection, p. 141 © Sandford H. Roth/Rapho, p. 142 © Philippe Halsman/Magnum Photos, p. 143 © Getty Images/Gjon Mili.

Copyediting: Slade Smith
Typesetting: Thomas Gravemaker
Proofreading: Helen Adedotun
Color Separation: Penez Édition, Lille

Distributed in North America by Rizzoli International Publications, Inc.

Simultaneously published in French as Les Chats vus par les grands photographes, © Éditions Flammarion, 2005
English-language edition, © Éditions Flammarion, 2005

05 06 07 4 3 2 1

FC0496-05-X
ISBN: 2-0803-0496-8
EAN: 9782080304964
Dépôt légal: 10/2005

Printed in France by Pollina - n° L97522